# THE SUNDERLAND COTTAGE

## A HISTORY OF WEARSIDE'S 'LITTLE PALACES'

MICHAEL JOHNSON

AMBERLEY

This book is based on research funded by the Durham Victoria County History. I would like to thank Gill Cookson and Graham Potts for their assistance in preparing the study. I am indebted to the late Norman Dennis for information regarding his involvement in the Millfield controversy. I am also grateful to John Tumman for making valuable comments on the text and providing insight into matters of planning policy. Thanks are due to the staff of Tyne and Wear Archives Service for making available over 600 documents from their collection and to Sunderland Antiquarian Society for permission to reproduce photographs. I would like to thank Matthew Bristow of the Institute of Historical Research for digitising the map showing the distribution of Sunderland cottages.

This edition first published 2015

Amberley Publishing, The Hill, Stroud
Gloucestershire GL5 4EP

www.amberley-books.com

British Library Cataloguing in Publication Data.
A catalogue record for this book is available from the British Library.

ISBN 978 1 4456 5375 4 (print)
ISBN 978 1 4456 5376 1 (ebook)

Typesetting and Origination by Amberley Publishing.
Printed in Great Britain.

# Contents

# Introduction

Britain's towns and cities experienced a dramatic rise in population during the nineteenth century, as people came seeking work in emerging industries. In many parts of the country this created a demand for housing that far exceeded the existing supply. Various housing types were developed to fulfill this urgent need: back-to-backs in the West Riding of Yorkshire, tunnel-backs in the East Midlands, tenements in Glasgow and Tyneside flats around Newcastle. Faced with the problem of housing its working population, Sunderland in County Durham developed a unique form of single-storey terraced houses that came to be known as Sunderland cottages.

The Sunderland cottage can be understood as a 'terraced bungalow' and became the town's dominant housing type during the nineteenth century. Row upon row of these distinctive single-storey dwellings were laid out in tight grid patterns to accommodate workers and their families [Fig. 1]. The form was favoured by the skilled workers of Sunderland's shipyards and represented an affordable housing type that provided a high degree of privacy and social status. Each had its own entrance and backyard, and many of the best examples had private gardens,

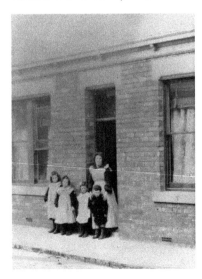

Fig. 1: Margaret Harrison and children posing for a photograph at Hazeldene Terrace, Pallion in 1906.

enabling residents to emulate the living standards of the middle classes. Examples occur throughout Wearside and as far away as Darlington; similar houses can even be found in working class areas of Dublin. Yet the form is most readily associated with Sunderland and contrasts dramatically with housing forms that emerged in other towns and cities during the nineteenth century.

The earliest cottages were built close to industrial sites such as Wearmouth Colliery, the shipyards and James Hartley's glassworks in Millfield [Fig. 2]. Later examples can be found in the suburban areas of High Barnes, Seaburn, Roker and Fulwell, as transport improvements made it possible to live further from the workplace. Cottages were built over an extraordinarily long period of time. Conservative estimates have given 1840–1910 as the period during which cottage-building flourished, but the current research establishes that they were being built into the 1930s – much later than previously imagined [Fig. 3]. Indeed, after the Second World War, Sunderland Council built a number of cottages to replace bomb damaged properties.

The new housing proved extremely popular in Sunderland, providing many workers with an opportunity to escape from the slum conditions of their previous dwellings by renting or buying their home. The proportion of working class home owners in Sunderland at that time far outstripped that in comparable towns and cities. Combined with Victorian house pride, this meant that many properties were kept to an excellent standard and contributed to the improvement of living conditions throughout the town. The most developed cottages embodied the aspirational values of Sunderland's artisanal class and facilitated the upward mobility of its working population.

This book examines the history of the Sunderland cottage, tracing the evolution of the form and examining its place within the town's social and architectural history. The research draws on an extensive collection of building plans preserved by Tyne and Wear Archive Service (TWAS), which has not previously been subjected to systematic analysis. The study concentrates on areas that have been comparatively under researched and presents a number of key findings: firstly,

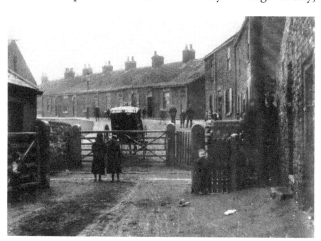

Fig. 2: Early cottages at Lisburn Terrace, Deptford. © Sunderland Antiquarian Society.

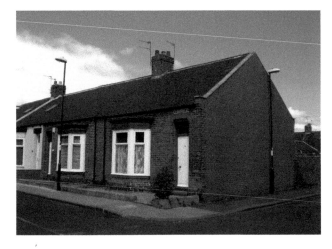

Fig. 3: Later cottages in Inverness Street, Fulwell.

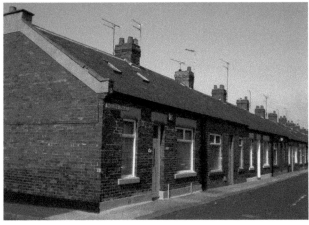

Fig. 4: Well-preserved double-fronted cottages at Hazeldene Terrace, Pallion.

that industrialists were involved in the development of cottages as speculators (though not as philanthropists); secondly, that the form persisted much longer than previous publications have suggested; and thirdly, that architects were intimately involved in both the planning and the design of cottages.

The Appendix takes the form of a database organised alphabetically by street, which presents salient data on cottage-building gathered from building plans. These documents reveal who was responsible for designing and building cottages and when they were constructed. The Appendix provides reference numbers for over 600 architectural plans and will serve as a valuable starting point for cottage residents eager to research the history of their house, as well as any historians with an interest in Sunderland's nineteenth- and early twentieth-century housing.

The Sunderland cottage is now recognised as an important and distinctive approach to housing Britain's expanding urban population. Well loved by residents, the best of these houses exemplified the pride of Sunderland's elite workforce [Fig. 4]. They remain a popular housing type to this day, both as starter-homes and as long-term residences, and comprise a substantial portion of the city's housing stock.

# Origins

Sunderland developed from three smaller settlements clustered around the mouth of the River Wear on the North East coast. The oldest was Monkwearmouth, a monastic settlement on the north bank of the Wear, dominated by the Saxon church of St Peter. South of the river was the medieval parish of Bishopwearmouth. To the east lay the 'sundered land', so called because it was divided from the lands of the Wearmouth monks by the river. This area was designated Sunderland parish in 1719, and the township began to spread westwards, eventually fusing with the older parish of Bishopwearmouth. The building of Wearmouth Bridge in 1796 joined these areas with Monkwearmouth to the north. From this point on Sunderland was increasingly recognised as a single town, and the three parishes were officially incorporated into Sunderland Borough in 1835 [Fig. 5].

By this date, Sunderland had developed into a major industrial centre. Shipyards, collieries, potteries, iron foundries and glass works proliferated throughout the town, employing thousands in skilled and semi-skilled labour. Most of Sunderland's major industries depended upon coal. Beginning in the seventeenth century, coal from across the Durham coalfield was transported down the Wear to Sunderland in flat-bottomed keels, before being transferred into collier brigs and shipped down the coast. New railways and wagon ways facilitated this process. Wearmouth Colliery, at one time the deepest coalmine in the world, began producing coal in 1835, and the South Docks were built in 1850 to allow ever greater quantities to be transported [Fig. 6]. Ancillary trades developed in response to this burgeoning industry. A notable success was James Hartley's glassworks, established in 1837 at Millfield [Fig. 7]. Glass was Sunderland's leading export after coal and salt, and by 1850 Hartley was producing a third of all plate glass made in Britain.[1]

Sunderland's greatest industry was shipbuilding, which was well established by 1717 when the River Wear Commission was founded. The Commissioners dredged the river and made a series of improvements to its infrastructure. Private companies built the South Pier (1726–59) and North Pier (1788–1802), as well as the North Dock (1837), Hudson Dock (1850) and Hendon Dock (1868). These

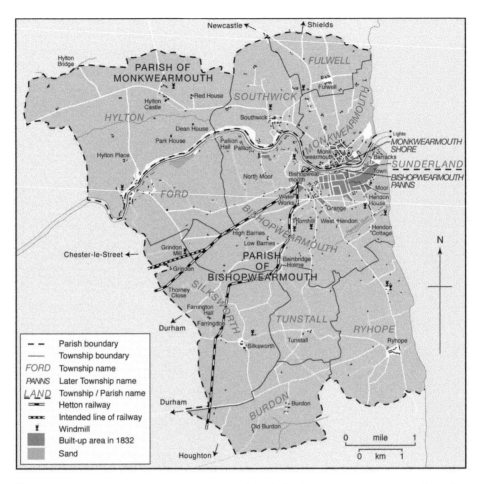

Fig. 5: Map showing the constituent parishes of Sunderland in 1832. © University of London: Cath D'Alton.

were significant feats of engineering which transformed Sunderland's commercial prospects. During the nineteenth century shipbuilding became Sunderland's dominant industry. Scores of shipyards lined the river banks at Deptford, Pallion and Southwick and were initially occupied with the construction of wooden vessels, including some of the finest tea clippers in the world. According to Lloyd's Register of Shipping in 1834, Sunderland was 'the most important shipbuilding centre in the country, nearly equalling, as regards number and tonnage of ships built, all the other ports put together.'[2] Adapting to new technologies, the town's first iron ship was built in 1852 and steel ships were being produced by 1882. Shipbuilding was key to the town's identity and a major source of pride to workers and their families. Indeed, Victorian Sunderland regarded itself as the largest shipbuilding town in the world.[3] Sunderland became the commercial centre of County Durham and developed an elite workforce attracted by some of the highest wages in the country [Fig. 8].[4]

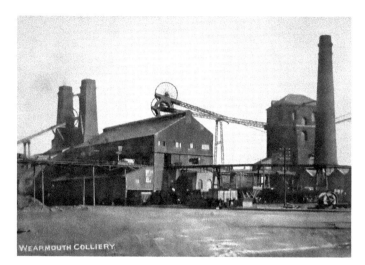

Fig. 6: Wearmouth
Colliery.

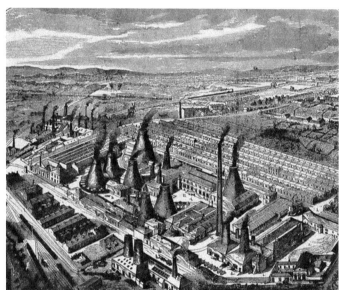

Fig. 7: James
Hartley's Glassworks.
*Scientific American*,
supplement 99, 24
November 1877.

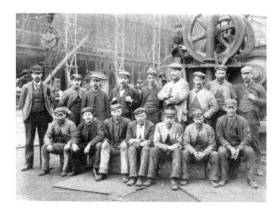

Fig. 8: Platers at Bulmer's shipyard in
the 1900s. © Sunderland Antiquarian
Society.

Accompanying this groundswell of industrial activity, Sunderland experienced a dramatic rise in population. From a figure of 26,511 in 1801, the number of inhabitants rose nearly sevenfold to 182,260 in 1901.[5] These figures were inflated by boundary expansions that occurred at various times throughout the century, but the undoubted rise in population created a pressing demand for housing. Initially, workers and their families tended to live close to places of employment, often in overcrowded and unsanitary dwellings. New and better housing was sorely needed. The scale of the problem is illustrated by the fact that the number of building firms listed in local directories rose from only three in 1822 to sixty-six in 1900.[6] Similarly, the number of architectural practices increased from one in 1822 to seventeen in 1902.[7] Extensive building work was accompanied by a growing awareness of the need for proper training and standards within the profession. Some attempts were made to provide housing that directly tackled the sanitary and health problems from which the town suffered. The development of the Sunderland cottage, combined with these improvements in the building trade and the architectural profession, provided an alternative to the slum dwellings of the previous generation and helped to raise living standards within the town.

## Housing in Sunderland

Traditionally, the provision of housing had largely been the preserve of builders working from pattern books and using well-established practices, while architects were involved only with grand houses for wealthy clients. This pattern was true in Sunderland in the early part of the century – the first housing was erected by builders with little or no formal architectural training. The provision of housing was shaped by the middle classes, who had the resources to choose where they lived and in what sort of houses. From the eighteenth century, the well-to-do moved away from the original settlement around the port in Sunderland parish and gravitated towards Bishopwearmouth, especially onto the nineteen acre Fawcett estate. Modelled on the elegant terraces of London, Edinburgh and Bath, the houses in Fawcett, John, Frederick and Foyle Streets were intended for professional middle-class families and most featured basements for servants [Fig. 9]. By the 1850s, Fawcett Street was developing into a commercial thoroughfare and gradually became less attractive to middle class residents. Consequently, the area to the south of the town became highly desirable and the Mowbray estate was developed in the 1850s with salubrious terraces of two or three storeys. Development continued, and the leafy suburb of Ashbrooke became the favourite site for middle class residents.

Amidst all of this development, the working people of Sunderland had little say as to where they lived or what form their housing took. Workers' housing was fitted into sites not claimed by the wealthy or by industry. Speculative builders erected housing of various types close to the mines, shipyards and docks, enabling the workers to walk to their place of employment from their homes [Fig. 10]. It is worth noting, however,

Fig. 9: Salubrious
middle-class housing
in John Street on the
Fawcett estate.

that speculative builders were not solely responsible for the development of housing –
a small number of industrialist landowners provided housing on a commercial basis.
At Monkwearmouth, for example, Sir Thomas Hedworth Williamson built around
400 houses in the area around Dame Dorothy Street and these were praised by
government health inspectors as being of a high standard.

Some builders created alternatives to the Sunderland cottage. There are
a number of Tyneside flats in Fulwell Road, Balmoral Terrace in Grangetown,
John Candlish Road in Millfield, Gladstone Street in Monkwearmouth, Ferndale
Terrace in Pallion, Sandringham Road, Sandringham Terrace, Bede Street and Park
Gate in Roker, and Carley Road in Southwick. Where businesses built directly
for their own workforce they followed the patterns they had already established.
The North Eastern Railway Company built housing for many of its staff. William
Bell, the company architect from 1877-1914, provided standard NER designs for
houses in Lyndhurst Road, Pallion and at Southwick. The local architect Joseph
Potts supervised their construction.[8]

In other towns, a common way of building superior dwellings for workers was
through the Land Society Estate movement. Freehold land societies came into
existence in the 1840s as part of a Liberal programme to effect Parliamentary
reform. These societies acquired sites and then built houses with a rateable value
sufficient to gain the occupier a parliamentary vote. Although their motivation was
primarily political they built better than average houses. A branch was formed in
Sunderland in 1849 by the Liberal 'great and good' of the town. Among its founders
were Henry Binns, Joshua Wilson, James Williams and John Candlish. A number
of cottages were built by the Society and occupied by its members. This was on
the north side of Hylton Road, where Joseph Potts laid out an estate in 1852.[9] The
*Sunderland News* of 9 October 1852 recorded the laying of the foundation stone of
the first cottage by George Booth in what came to be Pickard Street. The ultimate
occupier was William Pickard, hence the name Pickard Street.[10]

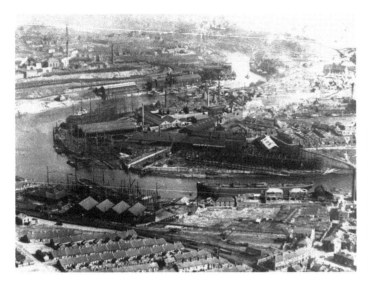

Fig. 10:
Cottages built
near Pickersgill's
east shipyard in
Southwick. Sir James
Laing's Deptford
yard is visible at
the centre of the
photograph. ©
Newcastle Libraries.

Another way to find designs for model houses was to organise competitions that would attract young architects to design improved houses within the budget set in the rules. This does not seem to have been widely attempted in Sunderland, but in 1872 the Corporation held a competition for houses to be built on cleared land at James Williams Street. Sixty designs were received, and premiums were awarded to the architects Thomas Oliver and John Tillman, but these were for two-storey designs.[11] This appears to have been Sunderland's first housing 'redevelopment'.[12]

The poorest residents had to live in adaptations and infillings of the existing housing stock. This produced the overcrowded slums for which Sunderland was notorious [Fig. 11]. No architect was involved with these desperate solutions to the housing problem. Nor were professional architects keen to design new housing for the working classes until there were changes in the legislative framework to tackle the worst excesses of bad health and slum housing. In the summer of 1831 Sunderland experienced an outbreak of cholera. The first confirmed case was that of William Sproat, a keelman who lived near the quayside. The virulence of the infection was exacerbated by cramped and unhygienic living conditions, unsatisfactory sewerage and contaminated water supplies. The outbreak resulted in 215 reported deaths in Sunderland, and soon spread throughout the country. A second outbreak in 1848 demonstrated that the issues that had made the epidemic so deadly had not been addressed.[13]

## The First Cottages

Patterns of housing development in Sunderland were comparable to those in many other towns and cities in Britain during the nineteenth century. From around 1840, however, a distinctive form of workers' housing emerged. Terraces of single-storey cottages are virtually unique to Sunderland and contrast with the workers'

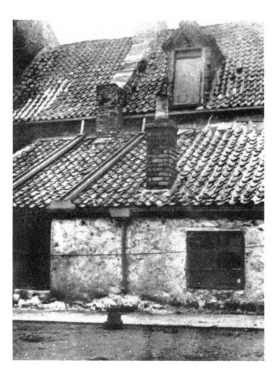

Fig. 11: Dilapidated housing at
Dundas Street, Monkwearmouth. These
were typical of the 'cruel habitations'
that preceded the Sunderland cottage.
© Sunderland Antiquarian Society.

dwellings of other industrial areas such as Tyneside flats, or the back-to-backs of
West Yorkshire.

The origins of the Sunderland cottage are difficult to uncover, firstly because
many of the earliest examples have been demolished, and secondly because the form
pre-dated the establishment of a formal architectural profession in Sunderland,
meaning that no plans of the earliest cottages exist.[14] An early influence on the
cottage form may have been the County Durham pit row, a traditional form of
miners' housing that became a fixture of the industrial landscapes of North East
England. Like Sunderland cottages, pit rows were often built as single-storey
terraces, though some were two-storey dwellings.

The internal planning of the pit-row house was less sophisticated than that
of the Sunderland cottage, often consisting of a single room. The toilet was
usually located on the far side of the road, rather than being enclosed within
a backyard as in the Sunderland cottage. Nevertheless, there are similarities.
Echoing a characteristic feature of the pit row, several cottage streets have two-
storey houses at the end and these are often adapted for use as shops [Figs. 12
and 13]. Examples of two-storey end houses may still be seen at Sorley Street
in Millfield, each built by William M. Skinner, who seems to have specialised in
building corner-shops.[15]

It is likely that pit rows were introduced to Sunderland by the Monkwearmouth
Coal Company, which built a substantial amount of colliery housing in the 1840s
and 50s. These would have served as useful models for the speculative builders
who erected the first Sunderland cottages. Pit-row houses were in turn based on

Fig. 12: Typical
large end-house at
Hazeldene Terrace,
Pallion.

Fig. 13: End house
at No. 160 Fulwell
Road operating
as a corner-shop.
© Sunderland
Antiquarian Society.

agricultural cottages, and this fact supports Sutcliffe's theory that many forms
of nineteenth century urban housing were based on earlier rural forms that had
persisted into the industrial era. Sutcliffe argues that these established forms
endured because builders and prospective residents were familiar with them,
and as a result the form was passed down from generation to generation.[16] Rural
estates and mine-owners built strips of single-storey cottages in Northumberland
in the nineteenth century. The cottages on the Percy estate are of this type, for
example. Similar housing was built in the coastal village of Whitburn, north of
Sunderland [Fig. 14]. Another possible source of influence was the single-storey
housing that prevailed in rural parts of Scotland and which often featured a
projecting dormer window in common with many of the later cottages. Similar
single-storey housing can still be found in another east-coast town, Dundee.

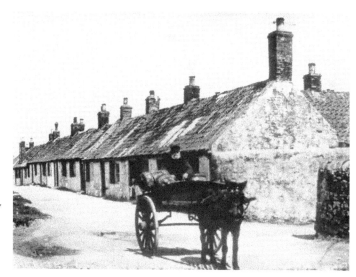

Fig. 14: Single-storey
fishermen's cottages
at Whitburn Bents.
© Sunderland
Antiquarian Society.

Sunderland cottages were built throughout the town and it is possible to trace the broad patterns of development [Fig. 15]. The earliest surviving cottages were built in the Millfield area and date from the mid-1840s. These were mainly built for workers at James Hartley's glassworks. Similar cottages were built at Southwick and Monkwearmouth to provide accommodation for shipyard and colliery workers. These tended to be single-fronted dwellings with simple architectural features, sometimes in the form of round-arched doors and windows. As the shipyards at Monkwearmouth prospered, housing was built on land between the River Wear and Roker Avenue.

The largest scheme was that pursued by Sir Thomas Hedworth Williamson, the dominant landowner in Roker and Monkwearmouth, who planned an estate in 1851–57. Williamson had already commissioned the celebrated Newcastle architect John Dobson to plan developments on Monkwearmouth Shore in conjunction with a new road to serve his North Dock in 1835, but he was later to produce a much larger scheme.[17] His development on a ballast hill in East House Field produced an estate of nine streets (Ann, Barrington, Bloomfield, Dame Dorothy, Dock, Hardwick, Mulgrave and Normanby Streets, as well as Milburn Place). The street layouts and house plans were drawn by Dobson with the intention of establishing a standard design. Dobson designed two-storey housing with basements in a regular grid, which was viewed as a 'decided improvement on the domestic architecture of the neighbourhood', though it does not look very different from much workers' housing of the period.[18] In the 1870s, Williamson also developed land to the north of Roker Avenue, with his land agent drawing up the layout, and then selling plots to local builders who built to the standard designs.

Early cottages survive at Hendon, where they mirrored the southward development of Hendon Docks. Between 1851 and 1867 parts of Hendon lay outside Sunderland Borough and thus beyond the jurisdiction of the Sanitary Authority. As a result, housing within these areas was built to a lower standard

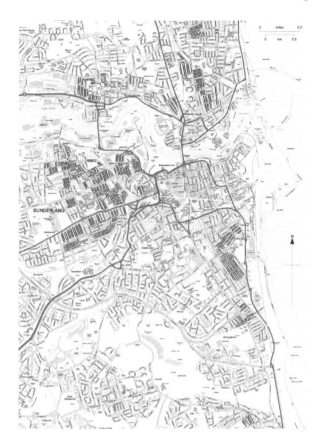

Fig. 15: Map showing the major concentrations of surviving Sunderland cottages within the city (N.B. cottages were also built beyond the confines of this map). Crown copyright Ordnance Survey.

and was often unsanitary. The development of the Middle Hendon estate began in 1865 at the instigation of the Universal Building Society, one of many small local societies sponsoring such developments. Uniform design and high standards were adopted, which partly accounts for the higher incidence of owner occupancy in this area. Hendon features particularly long terraces that run parallel to the railway – a geographical feature that results in distinctive streetscapes, as at St Leonard's Street and Cairo Street [Fig. 16]. Towards the end of the nineteenth century, the growth of a tram system allowed workers to travel cheaply and this encouraged the development of cottages in the new suburb of High Barnes. An attractive tram shelter with public toilets was built at the corner of Kayll Road and Chester Road in 1906. The tram system also gave working people access to leisure facilities in the town centre and the promenades on the seafront.

## Legislation

Working-class housing in Britain was immensely varied before 1850. After this date, however, towns and cities began to use more regular forms. Due to the pressures of industrialisation, local authorities were forced to control working-

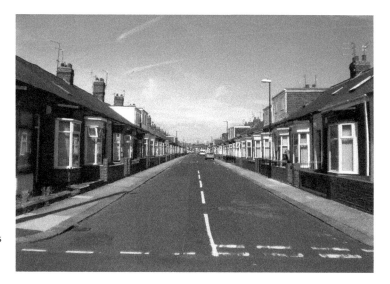

Fig. 16:
Exceptionally
long terraces
at Cairo Street,
Hendon, built by
the Wearmouth
Coal Company as
part of the 'Little
Egypt' estate.

class housing by issuing regulatory bye-laws. In some cases the new bye-laws discouraged distinctive regional housing types, but a small number persisted, and in such cases the new bye-laws tended to codify these traditional forms, ensuring their continued importance.[19] Indeed, the Sunderland cottage can be regarded as pit-row housing formalised by the Sunderland bye-laws.

It remains unclear why single-storey terraces such as these were favoured over the more economical practice of building two-storey properties that could then be sub-divided. Supporters of the Sunderland cottage have emphasised the degree of privacy obtained by allocating each property its own backyard and sanitary facilities, and by being too small to permit the introduction of lodgers [Fig. 17]. Similarly, the through-ventilation of houses with front and back doors gave an advantage over back-to-backs, and the universal provision of back lanes made for easy access by service providers like refuse collectors and 'nightsoil men', who would empty the contents of ashbins and toilets onto carts with shovels [Fig. 18]. Detractors have noted the monotonous appearance of terraced streets and the relatively large amount of land needed for each property. Indeed, a pair of back-to-backs required some 50 square yards of land, while two cottages separated by their back lane needed around 146 square yards.[20] The cottages would, in theory, have been unceconomical to build in terms of both land use and materials. This indicates that land in Sunderland was cheap to buy and develop at that time.

## Typology

The concept of the 'Sunderland cottage' gives an impression of homogeneity that is somewhat misleading. It is important to note that there were many different types of cottage within the basic model. Size and layout varied over time and according to location. The early cottages in Millfield and Pallion were single-

Fig. 17: Backyard
at No. 30
Deptford Terrace,
photographed in
1959. © Sunderland
Antiquarian Society.

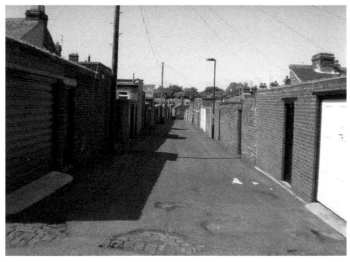

Fig. 18: Typical
back lane behind
Eastfield Street, High
Barnes.

fronted and had no bay windows or forecourts to set the houses back from the street [Fig. 19]. Smaller cottages in poorer areas were sometimes occupied by more than one family (e.g. Aylmer Street in Deptford). These modest dwellings would not have been as prestigious as the later, double-fronted cottages built at High Barnes, Roker or Fulwell, which often featured bay windows and forecourts [Fig. 20]. In short, there was a hierarchy within the form of the Sunderland cottage and this will be discussed in more detail later.

Although there is no 'typical' Sunderland cottage, it is possible to identify basic recurring features. Most cottages have a front door leading into a narrow passage.[21] One or two rooms lie immediately behind the frontage, with a kitchen and bedroom at the rear and a back extension containing a washhouse. Sanitary facilities were contained within a back yard bounded

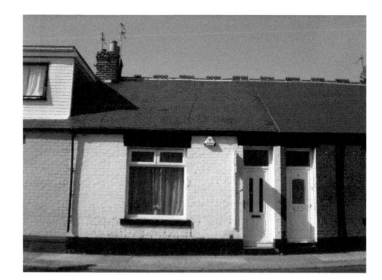

Fig. 19:
Single-fronted
cottage in Florida
Street, Pallion.

Fig. 20: Superior
double-fronted
cottages in
Laburnam Road,
Fulwell with bay
windows and
forecourts.

by walls about 7 feet high. The size of the cottages is deceptive. Although frontages are usually narrow, the houses tend to run a long way back and historians have commented that individual rooms are surprisingly large.[22] In a cottage in St Leonard's Street, for example, the living room measures 14 feet by 11 feet 3 inches; the bedroom 12 feet by 6 feet 9 inches; and the kitchen 15 feet 2 inches by 10 feet 9 inches [Fig. 21]. The architectural historian Stefan Muthesius estimates that, overall, a cottage offered more or less the same accommodation (500 square feet) as a Tyneside flat, a two-up-two-down in Manchester or a back-to-back in Leeds. The depth of the plot affects the quality of light within houses, but since the front and back are clearly distinguishable, cottages could be illuminated from the rear as well as the front, which gave them an advantage over back-to-backs.

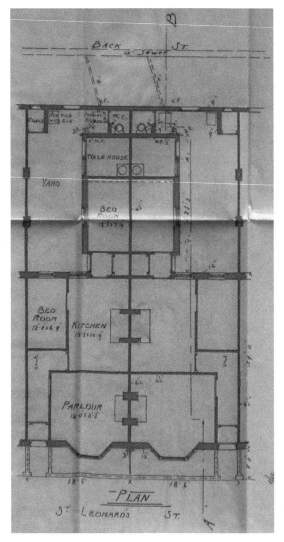

Fig. 21: Plan of two cottages in St Leonard's Street, Hendon, 1901, drawn by H.E. Robinson of the Wearmouth Coal Company. TWAS – 269/5894.

Most cottages had a back extension containing a washhouse and frequently an additional bedroom. In the interests of hygiene, coal sheds, ashbins and toilets were usually placed 'down the yard' to keep them as far from the house as possible. In adjoining houses, back extensions shared a dividing wall in order to keep the cost of materials down to a minimum. End houses presented a particular problem. The last plot in a street was often too small for a standard cottage, but builders developed various ways of maximizing the site. The front door could be placed on the end face if the nominal frontage was too narrow [Fig. 22]. Where two streets converged at an acute angle, more innovative solutions were needed: the rooms could be rearranged and a triangular yard substituted [Fig. 23]. The particular layout of the Sunderland cottage, with clearly-defined rooms each with separate corridor access, was designed to accommodate the nuclear family. In

1901 the average household size in Sunderland was 4.8 persons, and could just be accommodated by a two- or three-bedroom cottage.²³

The provision of a private entrance and backyard fulfilled the middle-class ideal of the self-contained family. As residents settled into cottage homes, the layout gradually encouraged individual family identities to take precedence over the more communal street identities that had been common in pit-row housing. Thus, cottages helped establish the insularity of the nuclear family as 'one of the principal mores' of British housing, in the words of Norman Dennis, who championed cottage housing during the controversial slum clearances of the 1960s and 70s.²⁴ Despite their small

Fig. 22: Cottage in Canon Cockin Street with the door on the end face to maximise the site.

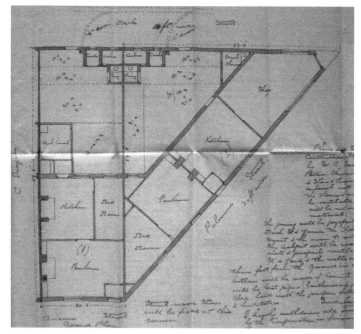

Fig. 23: Plan of two cottages and shop in Ancona Street in Pallion, 1882, showing innovative planning to exploit awkward sites.
TWAS – 269/95.

scale, then, the best Sunderland cottages were fully-formed private houses, allowing well-paid artisans to emulate the living habits of the middle classes.

## Shipwrights' Cottages

Sunderland cottages are closely associated with the town's artisans, particularly the shipwrights who earned Sunderland's reputation as 'the largest shipbuilding town in the world.' Indeed, shipbuilding accounted for 20 per cent of the town's workforce during the nineteenth century. Closely related to shipbuilding was the occupation of marine engineering, which represented another 15 per cent. Sunderland's skilled workers enjoyed relatively high wages. In 1882, for example, marine engineers could expect to earn around thirty-seven shillings per week, and by the end of the century shipwrights could earn two pounds per week.[25] Traditionally, Sunderland shipwrights were paid more than their Tyneside counterparts and this persisted until after the Second World War.[26] Increasingly, workers with a regular wage were able to move into cottage housing, which a Government Commission of 1845 described as 'single-storeyed cottages, occupied by one or at most two families, comfortable and cleanly, and furnished with small yards and other conveniences.'[27]

   The more sophisticated later cottages had the chief merits of middle class houses, albeit on a smaller scale. Thanks to this unique housing form, workers could purchase a dwelling with its own front door and backyard, and this encouraged the shift away from multiple-occupancy.[28] Thus, the Sunderland cottage opened the door to homeownership for the town's skilled artisans and their families [Fig. 24].

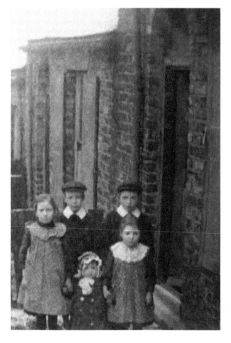

Fig. 24: Children outside a cottage in Woodbine Terrace, which was laid out in 1869. © Sunderland Antiquarian Society.

# Formative Influences

Sunderland cottages developed from the vernacular traditions of the Durham pit villages and were originally built in an uncoordinated manner, with no controls to ensure basic standards of execution. From 1851, however, cottage-building was regulated by Sunderland Corporation and its new legislative powers. The Sunderland Improvement Act of 1851 enabled the Corporation to take over the powers and assets previously held by the Improvement Commissioners. It also incorporated the provisions of the 1848 Public Health Act and applied them to Sunderland. Among these provisions was the appointment of a Medical Officer of Health and a Borough Surveyor. The surveyor's role was to enforce the newly written building regulations and to advise his Building Committee as to whether plans for new buildings met these regulations or not. Although the regulations dealt only with sanitary provision and basic minimum requirements of space and light, they were the first step in establishing appropriate standards of housing in the town. Crucially, they required plans to be drawn and submitted to the Corporation before approval to build could be granted.[1]

To evade these regulations, many builders developed sites outside the borough boundary in New Hendon, where they were free to build to whatever standards they chose. As a result, mortality rates rose in Hendon while those within the borough dropped.[2] While builders continued to dominate this field, architects became involved in the drawing of plans, especially for the layout of estates, and so became involved in the design of housing for the ordinary family.

Rather than prohibiting the cottage form, the bye-laws accepted it as an integral part of Sunderland's housing stock and merely sought to ensure that cottages were built to basic standards. Daunton has commented that municipal bye-laws often tended to 'freeze' development by restricting builders to a limited range of permissible housing types.[3] This was certainly the case in Sunderland: as one of the accepted models, the cottage type became an integral component of Sunderland's urban expansion.

## Building Regulations

The forms of legislation most commonly used to regulate cottage-building were the Improvement Act of 1851, the Public Health Act of 1875 and the local bye-laws. Regulations were primarily concerned with the thickness of walls and floors, the dimensions of rooms, and the situation of flues, fireplaces, stoves, toilets, ash pits and washhouses. The bye-law model was a three or four-room house with separate yard, toilet, ash pit and coal shed, and certainly the cottages built from *c.* 1865 onwards conformed to this template [Fig. 25]. Unfortunately, no plans drawn prior to 1865 have come to light.

Bye-laws determined the minimum street width: single-storey streets could be 30 feet wide, but one sixth of the street had to be utilised as a footpath on each side. Front streets were to be paved with square blocks at least six inches deep, which were then grouted with hot lime and sand and covered with pea gravel. Back streets were to be paved with 'whin chip blocks properly set in ballast and thoroughly beaten.'[4] At least four inches of ballast was to be laid under the paving stones, to compensate for the fact that much of Sunderland is built on clay.

In common with other towns, the Corporation sometimes struggled to enforce the bye-laws. It was particularly difficult to force speculative builders to lay out and pave streets prior to building, when no single builder had overall responsibility to do so and when in all likelihood any roads and kerbstones would be ripped up by gas and water companies when they laid supplies to the houses. In 1885 a proposed Corporation Bill was debated in Parliament and within Sunderland Council, containing a clause that landowners should be compelled to lay out streets. A notable opponent of this clause was Robert Preston, chairman of the Building Committee and mayor of Sunderland in 1884. He was described as 'a building landowner and not at all in favour of the proposed clause for compelling landowners to lay out and pave streets before building.'[5]

Bye-laws regulated construction and roofing, and demanded high standards of sanitation and ventilation in living spaces. Walls were to be built of brick 'properly bonded and put together with good cement.'[6] Rooms within the cottages seem to be unusually high, since the bye-laws fixed the ceiling height of all houses at 10 feet. Attic rooms had to be 8 feet high, meaning that they

Fig. 25: Section of a cottage in Abingdon Street, High Barnes, 1898. TWAS – 269/2. Note the timber roof structure, the position of air vents and provisions for connecting the house to the main sewer.

were just large enough to be converted into an additional bedroom, as many subsequently were. The 1850s bye-laws specified minimum window sizes and the 1875 Public Health Act stipulated that toilets should have a window in at least one external wall.

Further bye-laws demanded that every habitable room had a means of ventilation. Air vents were fitted in any room without a fireplace, which was counted as a means of ventilation [Fig. 26]. The average cottage had two fireplaces, one in the living room and another in the kitchen. Floors were to be at least twelve inches above ground, and the backyard was to have an inclination of one in thirty towards the back street, which was to be six inches below the level of the front street, allowing water to drain away.

For much of the nineteenth century, Sunderland had been notorious for the unsanitary condition of its dwellings. This was largely due to the widespread use of shared outdoor toilets or 'middens' that were emptied only three or four times a year. In 1867 there were reportedly 11,400 houses served by middens in Sunderland. Combined with other sanitary problems, the results could be horrendous. According to a damning report published in *The Builder*:

> On visiting New Hendon we found that the little Beck is crossed by an embankment some forty feet in height, known as Noble Bank. Now, this bank appears to be composed essentially of refuse of many kinds – furnace slag, cinders and ashes, sweepings of roads and gutters, and the contents of middens! The foul nature of the composition is disclosed by the condition of the water draining from the mass and collected at the toe of the slope resting on impervious clay, giving off countless bubbles of gas, and the whole water seems to be of the consistency of sewage in a concentrated form.[7]

The 1867 bye-laws demanded that each house must have a separate toilet or 'convenience.'[8] Today, the outside toilet is often seen as a sign of poverty, but in the Victorian era it was often considered advisable for the toilet to be separated from the house for reasons of hygiene.[9] In any case, the provision of one toilet

Fig. 26: Typical air vent under the front door of a cottage in Hemming Street, Grangetown.

per dwelling was a vast improvement on shared middens. Pipes from the toilet and washhouse were to be linked to a main sewer running along the front or back street: 'The waste pipe from the bath, sink or lavatory is to be taken through an external wall and to discharge in the open air over a channel leading to a trapped gully grating at least twelve inches distant.'[10] In practice, this was not always possible, as development often occurred in parts of the town that were not yet served by main sewers. In such cases, backyards were equipped with double hatches: one for coal and one for the privy. Examples of double hatches can still be seen at Wilson Street, Booth Street and Hume Street in Millfield. They enabled the night soil men to empty privies from the back lane without needing access to the houses themselves.

The coal hatch was at shoulder height, allowing for delivery of coal on regular days of the week except Monday, which was wash day [Fig. 27]. For this weekly occurrence, washing lines were strung across the back lanes to allow washing to be dried. In the late 1880s, Sunderland's Medical Officer of Health recommended that all remaining middens should be replaced with water closets and by 1914, as a result of these improvements, the number of houses with middens had been reduced to 119. As Daunton observes, Sunderland had leapt to the top of the sanitary hierarchy within a decade.[11]

A major concern was that cottages should not face onto the rear of any neighbouring street. To prevent this, the 1867 bye-laws specified that 'No such front street shall be constructed to be a back street on account of any such back door communicating herewith'.[12] Although this clause is somewhat unclear, it was nevertheless obeyed by those engaged in planning cottages: streets face inwards, producing narrow lanes at the rear. Moreover, the front and back of each house were visually distinct, and this clear differentiation gave the cottages a decided advantage over back-to-back housing, as it allowed each house to present a polite public frontage and to contain all sanitary facilities at the rear [Fig. 28].

The Sunderland bye-laws contained a number of clauses not found in national legislation. An 1858 Act of Parliament recommended that every dwelling should have 150 square feet at the back, and both Sunderland and Newcastle adopted this measure, but further stipulated that this space should be fully bounded by walls.[13] Thus, Sunderland cottages tended to have an enclosed backyard, and this additional area of defensible space gave them heightened territoriality and privacy. Bye-laws forbade all non-domestic use of dwelling houses – in other words no trade was allowed to operate within. The only exceptions to this rule were the end cottages built with shops in the ground floor. It was possible to convert cottages into shops if permission was obtained from the Corporation, and this happened in many cases [Fig. 29].

Significantly, some of the architects and builders involved in cottage-building were able to participate in the formulation of the bye-laws by joining the Architects' and Builders' Committee, a division of Sunderland Corporation. A report of a meeting of this committee was published in *Building News* in 1897 and gives an idea of proceedings. The committee met to consider how

Fig. 27: Coal hatch in the Pallion area.

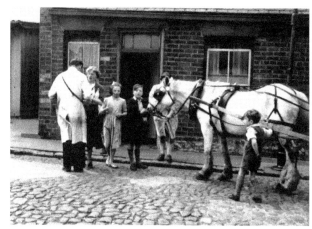

Fig. 28: Milk cart making deliveries in Hedley Street, Millfield. © Sunderland Antiquarian Society.

the Corporation should respond to the new bye-laws proposed by the Building Committee. The prolific cottage-builder Robert Hudson chaired the meeting; the builder J. W. White and the architect James Henderson were also present. The interests of local landowners were represented by a Mr Foster, secretary of the Land Owners' Property Association. William Milburn, architect and secretary to the committee, explained the proposed bye-laws. The committee unanimously accepted the proposals and recommended that the Corporation adopt them also.[14] This account indicates that local builders and architects were involved in developing the legislature that controlled house-building in the town.

## Land and Materials

To the casual observer, the Sunderland cottage may seem an inefficient way of building houses. Single-storey housing is not economical in terms of land or materials: a two-storey house on the same plot could provide twice as much

Fig. 29: Corner shop in Merle Terrace, Pallion. © Sunderland Antiquarian Society.

accommodation as a Sunderland cottage. Indeed, the floor space offered by a cottage was less than half that of the plot size. In order to understand why Sunderland favoured such an unusual housing form we have to examine the way land was used within the town. Most land in Sunderland was held by chief rent rather than as freehold. This meant that builders found it relatively cheap to acquire land for building plots. Muthesius estimates that the cost of land amounted to only 10 to 20 per cent of the builder's expenditure and the relative cheapness of land permitted the rather liberal use of space that characterised the Sunderland cottage.[15] It is also significant that while most national bye-laws stipulated that most streets should be 40 feet wide, the Sunderland bye-laws permitted single-storey streets to be only 30 feet wide. This means that cottages wasted less space than might be supposed.[16]

Building a cottage was also relatively cheap in terms of materials. The standard cottage was built of bricks manufactured from clay excavated from the Town Moor, and mortar was produced from local limestone deposits. Glass for windows was made by local manufacturers such as James Hartley and Co., a firm that dominated Sunderland's glass industry. The port of Sunderland ensured a steady supply of cheap timber from North America and the Baltic, and this was used extensively for internal construction, as well as windows and doors. In some cases, timber was used to produce high quality detailing such as heavy cornices and substantial door surrounds. Welsh slate was imported through the port for roofing. It is significant that Robert Preston, mayor of Sunderland in 1884, as well as chairman of the Building Committee, was one of the largest importers of Welsh slate in the North East.[17]

3

# Cottage Design

The form of Sunderland cottages developed over time. The main improvement was to build 'double-fronted' properties with two rooms at the front, flanking a central doorway. This permitted internal layouts consisting of two bedrooms and two living rooms, with the kitchen as an off-shoot in the yard. Bay windows and small front yards were sometimes introduced to set the entrance back from the street. The cottages in the 'Little Egypt' area of Hendon have front yards bounded by low brick walls and paved with attractive tiles [Fig. 30]. Occasionally, dormer windows were added to create additional bedrooms in the loft space. This gave the cottage a degree of flexibility that made it attractive to a range of potential occupiers [Fig. 31].

## Architectural Style

Victorian architecture was highly eclectic and a vast range of architectural styles were used for the new public buildings, churches and commercial buildings erected as part of Britain's unprecedented urban expansion. Some of these styles were reflected in Victorian housing and it is common to find terraces in classical, Gothic and Renaissance styles. At first glance, Sunderland cottages seem to exist below the threshold of 'polite' architecture, rarely exhibiting overt architectural styles. In the relatively limited literature on the subject, cottages are often regarded as little more than vernacular buildings, i.e. derived from indigenous traditions and craft processes. This is to be expected: builders operated on limited budgets and could not afford to reproduce elaborate stylistic details. Nor could they risk becoming embroiled in the contentious debates that surrounded issues of taste in Victorian architecture. However, close analysis reveals that a number of cottages emulate recognisable architectural styles, albeit crudely. Style is rarely consistent throughout an entire street because the cottages were usually built by different builders and this gave rise to variations in design.

Much of Britain's terraced housing follows the classical idiom. For example, the middle class housing on the Fawcett estate was inspired by the classical terraces of the eighteenth century. In most cases the Sunderland cottage follows this precedent and

Fig. 30: Colourful
tiles in St Leonard's
Street, Hendon.

Fig. 31: Section
of No. 17 Gilsland
Street, Millfield
showing an attic
and dormer window
to be added to the
property, 1896.
TWAS – 269/2492.

displays modest classical details [Figs. 32 and 33]. For example, the lintels over doors
and windows emulate classical architraves. Some cottages have a row of projecting
bricks just below the roofline, echoing the dentilled cornices that are common in
classical architecture. A prime example is Dickens Street in Southwick [Fig. 34]. In
common with most English terraced housing in the nineteenth century, then, the
majority of Sunderland cottages fall broadly within the tradition of neo-classicism.

Later developments introduced a range of decorative details. By the 1860s,
Gothic motifs had begun to permeate domestic architecture nationally, and
Gothic details are apparent in Ridley Terrace, Hendon, where several doors have
rudimentary arches in a northern Italian Gothic style, executed in brick [Fig. 35].
Today Ridley Terrace is one of only two cottage streets to be listed as buildings
of special architectural or historical interest. Gothic architecture of the High
Victorian period (*c.* 1850–70) often made use of coloured brick and stonework
to produce an effect known as 'structural polychromy'. A local example from
the field of commercial architecture is the extraordinary Elephant Tea Rooms in
Fawcett Street (1873–77), designed by Frank Caws. To a lesser extent, Scotland

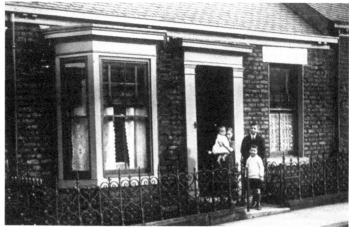

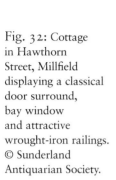

Fig. 32: Cottage in Hawthorn Street, Millfield displaying a classical door surround, bay window and attractive wrought-iron railings. © Sunderland Antiquarian Society.

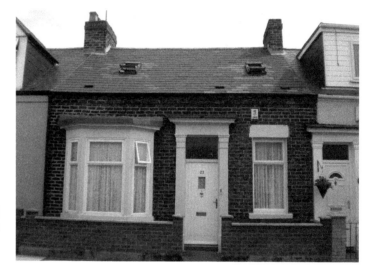

Fig. 33: Double-fronted cottage in Cromwell Street, Millfield with a severe classical door surround.

Street in Ryhope and James Armitage Street in Southwick (*c.* 1870) exhibit the bold polychrome brickwork characteristic of the period [Fig. 36]. Multi-coloured designs also occur in Paxton Terrace, Millfield, probably influenced by the larger houses at either end of the street.

## Ornamentation

In terms of ornamentation, the most elaborate houses occur in Rosslyn Street, Millfield and feature moulded arches and foliage around the doors [Fig. 37]. Attractive decoration and the presence of front gardens makes Rosslyn Street more akin to rural cottages than workers' dwellings. Another common feature is the round-headed arch, which would seem to align many cottages with either the Romanesque or Renaissance styles [Fig. 38 and 39].

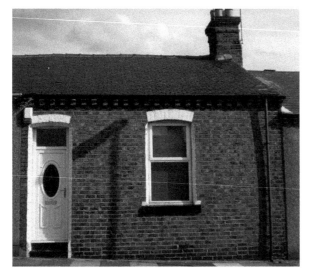

Fig. 34: Cottage in Dickens Street, Southwick with a row of moulded headers (projecting bricks) to simulate the dentils common in classical buildings.

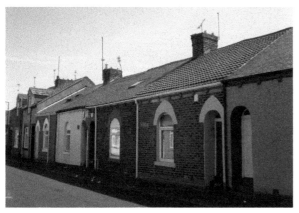

Fig. 35: Early cottages in Ridley Terrace, Hendon with Gothic arches over the doors and windows.

Fig. 36: Cottage in Scotland Street, Ryhope, exhibiting the colourful brickwork that was fashionable in this era, but rare within working-class housing.

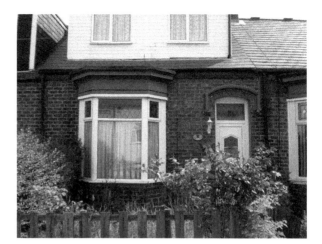

Fig. 37: Cottage in Rosslyn Street, Millfield. The bay window features a classical cornice and the doorway boasts a moulded arch with ball-flower decoration.

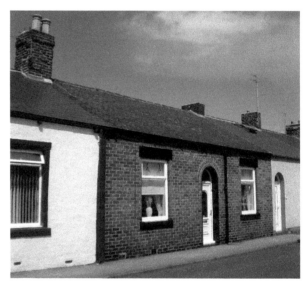

Fig. 38: Early double-fronted cottages in Osborne Street, Fulwell, boasting round-headed arches over the doors.

Fig. 39: Elaborately-moulded arches at Cirencester Street, Deptford.

It is likely that Sunderland cottages relied on local vernacular techniques for many of their decorative elements. Sunderland had many skilled woodworkers who crafted ornamentation for the ships built on the Wear. Some cottages exhibit high-quality detailing, particularly in the woodwork, and this was undoubtedly derived from techniques employed in Sunderland shipyards. Muthesius states that the 'exuberant woodwork of so many Victorian houses in Hull and Sunderland is in a class of its own,' and though he is speaking primarily of middle-class terraces, the tradition of expert woodworking did permeate down to Sunderland cottages.[1]

A key influence on the cottage form was the standardisation of fixtures. Driven by economic imperatives, builders increasingly utilised standard products and techniques. This made buildings cheaper and easier to execute; it also helped builders minimise the risks of the speculative system. As cottage-building became more standardised, it is likely that builders chose decorative elements from published sources such as pattern books or suppliers' catalogues. Published pattern books gave builders a wide range of decorative motifs that could be reproduced and incorporated into the design. A notable example was Cummings and Miller's *Architecture: Designs for Street Fronts, Suburban Houses, and Cottages, Including Details, for Both Exterior and Interior of the Above Classes of Buildings*, published in 1868. Not surprisingly, professional architects often disputed the quality of these publications and their value ultimately depended upon the builder being proficient enough to replicate the details accurately. Probably more important in Sunderland were catalogues produced by manufacturers in order to sell standard products such as shaped lintels and bay windows. Another mass-produced item that was widely used was 'Dr Quinn's Ash Bin,' which was installed in many Sunderland cottages and which allowed residents to dispose of ashes from the fireplace.

# Builders and Architects

As we have seen, the earliest Sunderland cottages were built close to bases of industry, enabling workers to walk to their places of employment. Despite the close link between workers' housing and sites of industry, it seems that no shipbuilders erected cottages for their workers. Indeed, it is generally supposed that very few industrialists engaged in cottage-building. As Angela Long, author of a pioneering study of the Sunderland cottage, has demonstrated, the speculative building system in Sunderland was so well developed that philanthropic housing was scarcely needed.[1] This was in sharp contrast to other industrial towns in this era. However, the present research has established that a significant number of industrialists did erect workers' housing on a commercial basis.[2] Industrialists, of course, had a vested interest in providing a large stock of affordable housing, as this helped to secure a stable, reliable workforce for their industrial enterprises.

A curious example occurred on the South Hendon estate. The Wearmouth Coal Company had planned to build a colliery south of the river. The plan never came to fruition and to reduce their loss, the company developed the site with housing. The company built twenty-four cottages in Cairo Street and twenty-five in St Leonard's Street. All of these houses were designed by the company's architect, H. E. Robinson. The Wearmouth Coal Company became the largest owner of domestic property in the town, possessing £3,888 rateable value, while 43.4 per cent of property in Sunderland was held by owners of £50 rateable value or less.[3]

These streets were built parallel to the railway line, producing unusually long terraces. High standards of design are evident from the bay windows, front yards and tiled paths. The adjoining Tel El Kebir Road was named after a decisive battle in the Egyptian Revolt of 1882. Because of the exotic street names, the South Hendon estate was known as 'Little Egypt.'[4] The estate was served by a tram line running along Ryhope Road to Villette Road, but it would have been difficult for miners working shifts at Wearmouth Colliery to use trams to get to work for night shifts.[5] In proximity to the colliery, the Wearmouth Coal Company built fifteen cottages in Empress Street (1880) to designs by J. and T. Tillman, architects of Sunderland Museum and Library.[6]

In one of the largest instances of cottage-building, James Hartley and Co. built eighty cottages in Rose, Violet and Trimdon Streets in Millfield on the site of the former glassworks in an attempt to recoup some of the company's losses after closure. Hartley's glassworks had prospered thanks to the invention of a method of manufacturing rolled plate glass that was patented in 1847. By the 1860s the glassworks employed 700 men. Following James Hartley's retirement in 1868, the firm was taken over by Hartley's son John. However, problems adapting to new technology and poor industrial relations with the workforce led to the closure of the glassworks in 1894.[7] The factory was dismantled to make way for housing in 1896 and James Hartley & Co. submitted several housing plans to the council. The development resulted in the so called 'Flower Streets', whose floral names belied their industrial legacy. Designed by James Henderson, these cottages were atypical in that they had a bedroom in the attic space and a projecting dormer window in the roof. As such, these can be regarded as one-and-a-half storey variants of the Sunderland cottage. The same architect, James Henderson, also designed houses and shops nearby on Hylton Road. These acted as a screen to hide the cottages from people passing along the main road.

## Speculative Building

Despite the activities of some industrialists, the majority of Sunderland cottages were built by speculative builders eager to capitalise on Sunderland's dramatic industrial expansion and the consequent demand for housing. Speculative building firms were providing cottages across the town in Pallion, Southwick, north of Roker Avenue, between Hylton Road and Chester Road and especially Hendon, as new industrial developments arose.[8]

Speculative building became an industry in its own right and by 1901 was the second largest employer in Sunderland, after shipbuilding.[9] Estates were planned out before development commenced and a small number of plans survive, showing how land was divided up. The holder of the land, often a builder, would employ an architect to draw up the estate plan and define the plots. These would then be sold or rented to individual builders. The same architect would usually provide plans for each block of houses. For example, the builder W. G. Browell employed E. Sidney Wilson to plan out the King's House estate in 1898. Wilson delineated an area to be developed as St Luke's Road and defined the individual sites on which cottages were to be built. In this case, Browell himself built twenty-nine cottages in St Luke's Road, all of which were designed by Wilson.[10] Similarly, William M. Skinner employed the architect John Eltringham to plan out Blackett Terrace on land he owned south of Hylton Road [Fig. 40]. Blackett Terrace is exceptional in being the only cottage street in Sunderland to have a gate at either end. This suggests that Blackett Terrace was conceived as a private road in order to circumvent

the bye-law stipulation that each street must be at least 30 feet wide. It may have been an attempt to copy private gated developments like Bede Terrace, making it an example of working class housing aspiring to middle class models. Skinner built a total of eight cottages in Blackett Terrace, with the remainder being erected by William Hunter.

Streets were built up in a piecemeal fashion, with builders erecting various numbers of houses – sometimes a dozen, sometimes only a handful. Vertical mortar joints and variations in design reveal this haphazard process. The result of this system was that streets developed gradually, often with gaps that were not filled for several years [Fig. 41 and 42]. The local MP Samuel Storey explained that in Sunderland:

> Land is not sold, it is let on a building rent to builders. The effect is that a building speculator has a street laid out. He lets to A, B, C, D, E, F and G. Some may have money, some may not, A and G build, their houses really are in a street, but other men do not go off, the plots are sold, other men hesitate, the street hangs fire and the consequence is we are left with streets with houses here and there and other houses will not be built for years to come.[11]

Any delay in selling the houses could cause severe financial problems for builders, and bankruptcies were common in the building trade. Consequently, some builders did not proceed with approved schemes unless they were confident of turning a profit. These patterns of speculative development were typical of many provincial towns.

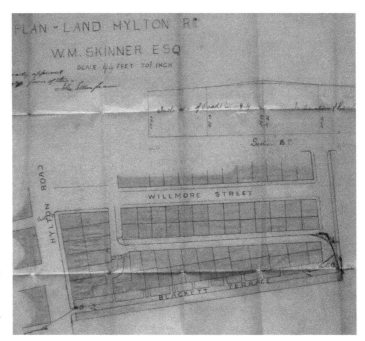

Fig. 40: Architects would draw up outline plans of blocks of houses for individual developers as here on an estate south of Hylton Road, 1887. TWAS – 269/544.

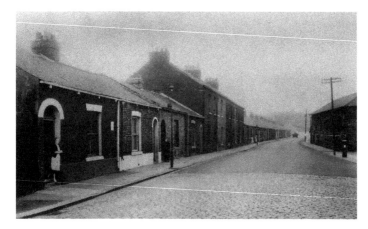

Fig. 41: Mixture of single and two-storey dwellings in Deptford Terrace, indicating that streets were often built up gradually according to different designs. © Sunderland Antiquarian Society.

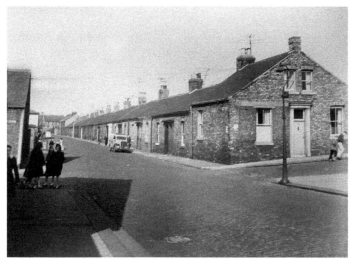

Fig. 42: Deptford Terrace in the 1940s. © Sunderland Antiquarian Society.

## Attribution

The role played by architects in the development of Sunderland cottages has been a subject of some debate. Historians have suggested that cottages were built by speculative builders without the aid of professional architects. Long, for example, states, 'The early history of the Sunderland cottage becomes, inevitably, anonymous history – for the form evades connections with individual architects or stylistic movements'.[12] This is also the view of Muthesius, who argues that it is now virtually impossible to find the names of the architects who designed working class housing.[13]

However, the present study has uncovered an extensive collection of building plans that were submitted to Sunderland Corporation for authorisation and are now preserved in the Tyne and Wear Archives, though they have not been formally catalogued. On close examination these reveal the names of builders and architects for many cottage streets [Fig. 43]. This evidence demonstrates that the

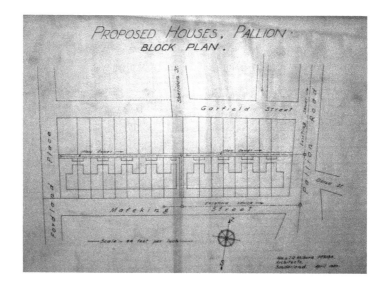

Fig. 43: Plan of
Mafeking Street,
Pallion, drawn
by W. and T.R.
Milburn. TWAS –
DT.TRM/3/147.

majority of cottage estates were designed by the town's professional architects
and thus share their provenance with Sunderland's major public, ecclesiastical and
commercial buildings.[14] Sunderland is not unique in this respect. Many prominent
local architects also designed workers' housing on a speculative basis. Others
acted as land agents and surveyors and this provided a lucrative backstop if more
prestigious work dried up. The reason it is difficult to attribute cottage designs to
specific individuals is that the architects themselves were not eager to publicise
their lower-class housing, even though it was a vital source of income, preferring
instead to base their reputations on more prestigious buildings.

Unfortunately, there are several cottage streets for which no plans have come
to light. This means that we can only obtain a partial view of building operations.
Sunderland Corporation initially did little to preserve plans submitted for
its approval; they were inadequately stored in the basement of Sunderland
Museum and Library until Tyne and Wear Archive Service was founded in 1974.
Similarly, the existence of a plan does not necessarily mean that the building was
constructed. Many plans were rejected by the Sanitary Committee of Sunderland
Corporation for contravening building regulations. In such cases, plans were
usually revised and resubmitted. Even approved plans could take a long time to
come to fruition, especially in times of economic depression. Builders frequently
spent capital on building land and obtained materials on credit from builders'
merchants, intending to repay once the houses were sold, but they would only
undertake this risk if their prospects were favourable. Except where noted,
the plans used in the current study were approved by the Sanitary Committee.
Furthermore, many of these plans feature handwritten notes documenting in
minute detail the day-to-day process of cottage-building: some give completion
dates for the roofing and plastering etc.

The earliest example of an architect planning a cottage estate that has come to
light is Martin Greener at South Dock Street, Hendon in 1857, showing that he

was prepared to design housing for all classes of the population.[15] Greener was best known for designing superior two and three-storey terraces, as at Grange Crescent (1851–55). The architect and builder George Andrew Middlemiss was also active in the field. Given his conservative views when he was a town councillor, and his vehement opposition to public health regulations, he took a strongly free market approach to building and so built on his own land in Hendon outside the Corporation's jurisdiction whenever possible. Having started his career in the building firm of J. C. Tone, who built many of the cottages around Wearmouth Colliery, he was well placed to be a major developer in the town. Aside from his architectural activities, he had built up substantial wealth as an auctioneer, appraiser and owner of the Cornhill Brick Works in Southwick. Thus, he could provide not only the plans for houses, but also the bricks to build them. In the 1870s he was building extensively in Hendon, and in the 1880s he laid out 350 houses in the Little Egypt estate off Villette Road and also an estate of 'superior' cottages on the Briery Vale estate off Tunstall Road.[16] He himself lived in the Gothic mansion Ashbrooke Tower (1875), which he designed for his own occupation.

Sunderland's foremost architects were the brothers William and Thomas Ridley Milburn, who were responsible for the design of the Empire Theatre (1907), as well as many other public, commercial and domestic buildings. Research has revealed that they were also highly active in the field of cottage design. The Milburns designed cottages in the 'ABC streets' in High Barnes (Abingdon and Barnard Streets, Colchester Terrace, Dunbar and Eastfield Streets, Farnham Terrace and Guisborough Street), as well as Kitchener Street, Nora Street, Hawarden Crescent, Queen's Crescent, Tanfield Street and Hampden Road [Fig. 44].[17] They also designed seventeen cottages in Broadsheath Terrace, Southwick and nine in Ancona Street, Pallion [Fig. 45]. On his own account, William Milburn produced the designs for Chester Street, Co-operative Terrace, Grindon Terrace and Dene Street. Similarly, Joseph Potts and Son had a substantial and varied practice in Sunderland. This firm was also a prolific cottage designer, providing plans for the 'Scottish streets' in Fulwell mentioned above – Forfar, Inverness, Moray and Roxburgh Streets.

It is significant that even where architects' plans survive, they rarely include views of the elevations of houses (i.e. frontages), only plans and cross-sections.[18] It is likely that the Corporation did not demand to see elevations, concerning itself only with internal layout and technical matters such as drainage, plumbing and ventilation. Builders utilised architects not for aesthetic guidance, but for their expertise in planning and their ability to navigate the bye-laws. In terms of the façade, the basic configuration of doors and windows was largely determined by the plan, which was drawn by the architect, but it seems that materials and decorative motifs were selected by the builder.

Most historians argue that Sunderland cottages ceased to be built after 1910. In fact, substantial numbers were built into the 1920s and even into the 1930s.[19] The vast majority of late examples were built under a scheme entitled 'Housing Assistance to Private Enterprise,' which was introduced by the Housing Estate

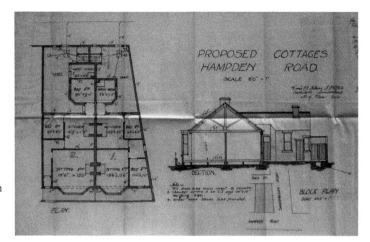

Fig. 44: Plan of cottages in Hampden Road, drawn by W. and T.R. Milburn. TWAS – 269/2787.

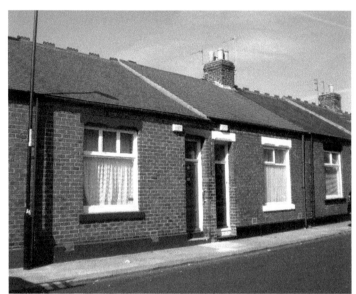

Fig. 45: Milburn-designed cottages in Ancona Street, Pallion.

Act of 1923, in which the government subsidised local authority housing. This initiative was used to build cottages in Forfar, Inverness and Moray Streets in Fulwell, Capulet Terrace, Canon Cockin Street, St Leonard's Street and Villete Path in Hendon, Kitchener Street in High Barnes, Grange Street in Grangetown, and Brady, Exeter, Mafeking, Mortimer and Reginald Streets in Pallion.

The largest concentration of new cottages was built in Fulwell's 'Scottish streets'. For example, Forfar Street was commenced in 1906, but was extended in 1925, principally by the builders C. B. Carr and C. R. Wills [Fig. 46].[20] The building of Inverness Street had begun in 1899, but a further forty-seven cottages were built between 1923–26.[21] Moray Street was built entirely between 1926–33, mainly by C. B. Carr. All of these new cottages were designed by Joseph Potts and Son [Fig. 47]. The north side of Mafeking Street, comprising twenty-one cottages,

was built by J. W. White in 1924.[22] In Hendon, St Leonard's Street was extended between 1924 and 1928.[23]

It is noteworthy that Sunderland Council built cottages after the Second World War in Duke Street North, Francis Street and Osborne Street in Fulwell to replace bomb damaged property. Furthermore, in the 1970s an adapted form of the cottage was built as infill in streets off Hylton Road, formerly part of the Freehold Land Association's development. The Department of the Environment was not favourably disposed to these properties at the time as they did not meet the current standards, but they were built nevertheless.[24]

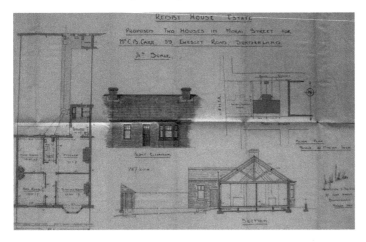

Fig. 46: Plans such as this, for new houses on Moray Street, 1926, indicate that Sunderland cottages were being built much later than previously supposed. TWAS – 269/4247.

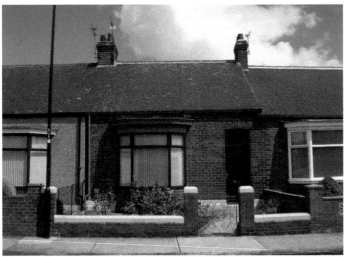

Fig. 47: Attractive cottage in Forfar Street, Fulwell, boasting a bay window and garden.

# A Hierarchy of Housing

To those unfamiliar with the form, Sunderland cottages may suggest poverty and hardship because they were small in scale and cheaply built. Within these constraints, however, the builders and architects who erected cottages were able to invest them with features that appealed to the aspirational values of Sunderland's skilled workers and their families [Fig. 48]. In an era of widespread overcrowding and tenement dwelling, privacy was highly prized, and it became a prime concern in the design of Sunderland cottages. Each property had its own front door, backyard and toilet. Rooms were clearly defined and accessed via an internal corridor known as the 'passage', which was a considerable improvement on the one-room tenement housing prevalent in the first half of the nineteenth century [Fig. 49]. Many cottages even had a small vestibule behind the front door, known locally as the 'Sunderland doorcase', which replicated the middle-class hall on a minute scale.[1]

This careful division of rooms was consistent with contemporary thinking on domestic living habits. For example, the architect and housing expert Robert Kerr (1823–1904) believed that housing conditions had a critical influence on the mental, physical and moral well-being of society and his ideas were widely accepted, even if some saw them as reactionary.[2] Despite their shortcomings, then, Sunderland cottages were far superior to the overcrowded tenements and back-to-backs that prevailed in other industrial areas.

## Owner-occupation

It is important to consider who lived in the first generation of Sunderland cottages. Street directories of the period show who was resident at each property and what their occupation was. This makes it possible to examine the social composition of each street. For example, the ABC streets in the High Barnes area were occupied by insurance agents, clerks, cashiers and merchants, revealing that this was predominantly a salubrious middle-class neighbourhood. A number of blue collar workers such as masons, joiners and marine engineers lived there too, indicating

Fig. 48: James Smith outside a
cottage in Brougham Street, c.1930.
© Sunderland Antiquarian Society.

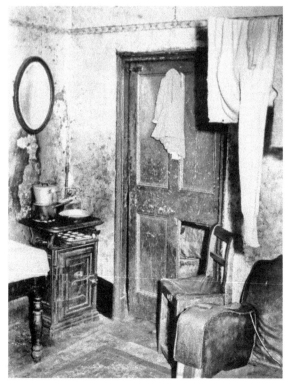

Fig. 49: Rare image showing
a cottage interior in Woodbine
Street, Pallion in 1953. ©
Sunderland Antiquarian Society.

that cottages gave workers a degree of social mobility.[3] Streets closer to bases of industry in Hendon, Pallion and elsewhere were predominantly occupied by blue collar workers engaged in skilled labour [Fig. 50].

Crucially, rate books from the period reveal that owner-occupation was widespread. Sunderland shipwrights earned higher wages than their counterparts in other parts of the country and this, combined with the abundance of small building societies, made it possible for many workers to buy their own home. Indeed, levels of owner-occupation in Sunderland far exceeded those in other towns and cities, reaching 35 per cent in Millfield and 80 per cent in Hendon, compared to a national average of just 20 per cent.[4] Daunton suggests that, overall, owner occupancy in Sunderland in the 1890s was at 27.3 per cent, significantly higher than other towns, but Longstaffe has shown that in the streets in his study the figures could be even higher: 50 per cent in Ridley Terrace and 86.6 per cent in Tower Street in an earlier period.[5]

To assist residents in buying their houses, Sunderland had dozens of small building societies that collected contributions from members, built houses with the funds, and allocated them to members by means of a ballot. These societies usually terminated once all members had been allocated a house. An example of such a scheme was that planned by the Universal Building Society in the Valley of Love in 1865. Houses to a total value of £35,000 were to be built in Mainsforth Terrace, Tower Street and Hendon Burn Avenue over three years by the builder J. C. Tone, creating the Middle Hendon estate [Fig. 51]. The houses were designed by John Tillman, whose important practice was also responsible for Sunderland Museum and Library in Borough Road (1879).[6] These were wide streets with good sewerage and sites earmarked for churches within the estate, and Tillman designed Mainsforth Terrace Primitive Methodist church (1867) around the same time. The scheme demonstrated that cottages could cater for the aspirations of the skilled working man.[7] Mainsforth Terrace is distinctive in having overhanging eaves and elaborate woodwork [Fig. 52]. Consistent design and high standards of execution contributed to the high proportion of owner occupation on this estate.[8] An advert for the Universal Building Society, printed in the *Sunderland Times*, commented that 'Hundreds of working men of Sunderland by successive unfelt shillings and sixpences … are becoming their own landlord'.[9]

There were also several instances of small-scale landlords owning one or two cottages and renting them out. Numerous small building societies owned multiple houses within a given street. *Ward's Directory* for 1901–02 lists sixteen such organisations, for example. Evidently, the ability to purchase one's home was a major point of pride among Sunderland's skilled workforce, suggesting that many inhabitants aspired to the domestic ideals of the middle classes. The Sunderland cottage earned the praise of the government: 'It is true that such cottages are costly to the town as involving greater expense in drainage and the upkeep of streets than houses of two or more storeys, but they constitute the favourite and typical dwelling of the skilled mechanic'.[10]

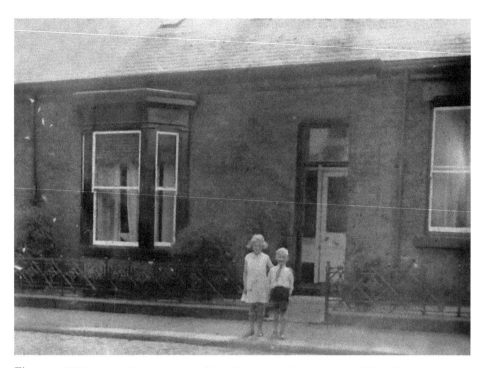

Fig. 50: Children outside a cottage in General Graham Street, Barnes. © Sunderland Antiquarian Society.

Fig. 51: Tower Street West was built by the Universal Building Society beginning in 1865.

Fig. 52: Cottages in Mainsforth Terrace West, Hendon display overhanging eaves and small front yards.

## Social Stratification

The design of Sunderland cottages varied over time and according to location. The various permutations reflect a complex social hierarchy within Sunderland's working population. The earliest examples were single-fronted – in other words only a corridor and one main room lay immediately behind the frontage. In time, double-fronted cottages became more prevalent, especially in more affluent areas such as High Barnes. In such cases, the front door is flanked by a living room and a front bedroom [Fig. 53]. Bay windows had become popular by the 1880s, and these signified higher status. This was partly because of the additional cost involved in fitting them, but also because they let in more light and air, elements greatly prized by Victorian health reformers and, presumably, homeowners. A projecting bay window also improved the defensibility of the house by giving greater surveillance of the street and making it easier to see who was at the front door. Some houses were built with a bedroom in the attic and this was signified externally by a projecting dormer window.

In general, very few working-class houses in the North East had gardens, but some of the more affluent Sunderland cottages had small front gardens bounded by walls or railings. Rosslyn Street in Millfield is the best example [Fig. 54]. In the nearby township of Silksworth, a large number of cottage streets have attractive gardens [Figs. 55 and 56]. This was because Silksworth was developed as a model colliery village by Lord Londonderry, who provided workers' housing around the pits and therefore away from centres of population. The shaft of Silksworth Colliery was laid in 1869 and the population of the area increased from only 400 in 1871 to 4,707 in 1879, mainly due to migration of people seeking work at the colliery. According to census returns, the miners who settled in the area hailed from Scotland,

Fig. 53: Double-fronted cottage in Barnard Street, High Barnes. The houses in the ABC streets were designed by Sunderland's pre-eminent architects, W. and T.R. Milburn.

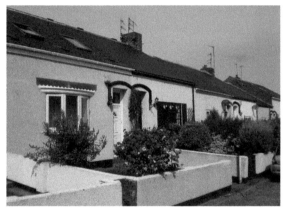

Fig. 54: Gardens in Rosslyn Street, Millfield.

Ireland, Germany and even the USA. William Forster acted as company architect and surveyor from the mid-1870s, designing houses and public buildings in the village. Long gardens occur in many mining villages, where they were usually provided by paternalistic land owners or developers as an antidote to drunkenness. Gardens also allowed miners to supplement their wages by growing their own food. Furthermore, Silksworth lay outside the Borough of Sunderland, meaning that it was not subject to the same building regulations, and this permitted the development of atypical forms.

Muthesius argues that although the gulf between rich and poor was widening during the nineteenth century, society became increasingly stratified, with complex subdivisions emerging among the working and middles classes. Muthesius attributes this situation to wage differences and the desire among sub-groups to assert their distinct social identity. Artisans were frequently paid more than the generality of workers and this was certainly the case in Sunderland, as we have seen.[11] This stratification is evident in the appearance of the town's working-class housing. In the new industrial communities – where so many houses were identical in scale – self-respect and outward status were vital. The Sunderland cottage allowed occupants to display their status and respectability to neighbours

Fig. 55: Gardens in Seaham Street, Silksworth.

Fig. 56: Gardens in George Street, Silksworth.

and passers-by. A key focus of social aspiration was the parlour, the front room kept in a pristine state and used only for special occasions and for receiving guests. This space thus functioned as a lower-class version of the drawing room. As one observer of Sunderland housing stated:

> In the midst of all these disadvantages, the visitor of the poor meets with numerous instances of determined struggles for cleanliness and general purity of character, and even moral heroism of a high cast, indicating that there is an effort to stem the general effects of poverty and that commendable self-respect is not worn out.[12]

Street names were a sign of social standing. The denomination 'Street' was standard, but 'Road', 'Crescent' and 'Terrace' all conveyed notions of greater status.[13] To take one example, Hawarden Crescent was laid out in a crescent shape between 1900 and 1911 on land formerly owned by the Reverend William Ettrick. The first two cottages in the street were built for John George Walker at a cost of £245 each. It appears that, as the first resident, he was invited to name the street. A staunch liberal, Walker choose the name 'Hawarden' in reference to the residence of Liberal Prime Minster William Ewart Gladstone. Various authorities

determined the names of cottage streets and builders were expected to provide and fix the name plates. This practice became integral to the structuring of social identity in Sunderland. At first glance, then, Sunderland cottages may seem to suggest poverty, but on closer inspection they reflect a complex hierarchy within Sunderland's working population.

## An Annexe to the Workplace

However, the picture looks rather different when compared to patterns of middle-class housing. Surveying Sunderland's urban structure, the sociologist A. H. Halsey described the town's housing as 'an annexe to the workplace'.[14] As we have seen, the first cottages were built close to bases of industry. This was largely due to the opportunism of speculative builders and partly because industrialists built houses for their workers. Both parties recognised that it was vital that occupants were able to get to work quickly and cheaply.

Cottages, and working-class dwellings in general, had to fit into areas that had not already been acquired by the middle classes, and this could give rise to social segregation.[15] Outwardly, Sunderland cottages are recognisably working class: the low-rise dwellings, with their continuous roofscapes, are visually and spatially separate from middle-class neighbourhoods. The disparity is exemplified by the severe contrast between the cottage streets in Hendon and the more affluent housing in the leafy avenues of Ashbrooke. Long observes that recognisably working-class housing reinforced the exclusivity of middle-class residences and gave physical form to the town's social structures.[16] Indeed, it is likely that the layout of streets was designed to discourage interaction between classes [Fig. 57]. When cottage streets are mapped out within Sunderland's townscape, it becomes clear that their axes do not generally communicate with the surrounding middle-class streets. For example, Hendon was forcibly divided from Grangetown and

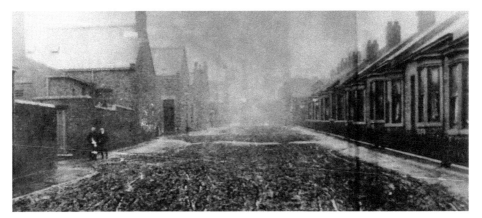

Fig. 57: Cottages in Fulwell, laid out perpendicular to streets of larger dwellings. © Sunderland Antiquarian Society.

Ashbrooke by the railway line, and the character of these areas is very different despite their proximity. Thus, while artisans welcomed the cottages as a definite improvement on Sunderland's notorious slum conditions, social divisions between classes were to some extent preserved by the form.

This division became less pronounced over time. Sunderland's transport network was improved by the addition of tram services between the town centre and the suburbs [Fig. 58]. The first tram system was constructed in 1878 and electric trams were introduced in 1896.[17] This caused the geography of Sunderland cottages to become more diffuse because houses could now be built further away from bases of industry. Sunderland trams initially operated with a fixed fare of two pence per journey, making it possible for workers to commute. As a result of these factors, cottages began to appear in suburban areas and gained additional cachet from their proximity to middle-class neighbourhoods and amenities. The High Barnes estate, including the ABC streets, is characteristic of the superior cottages built around the turn of the century [Fig. 59]. They were also part of a well-developed framework consisting of two churches, a school and a library. Together these institutions offered spiritual and intellectual improvement and defined High Barnes as a respectable neighbourhood where workers and their families could cultivate a middle-class identity.[18]

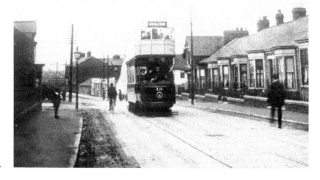

Fig. 58: Stockton Terrace in 1905. The development of tramlines led to the building of cottages in suburban areas. © Sunderland Antiquarian Society.

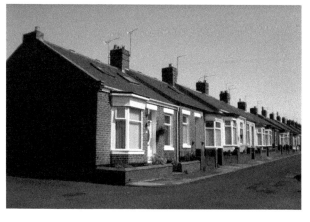

Fig. 59: Superior cottages in Abingdon Street, High Barnes. These are double-fronted cottages with bay windows and walled front yards to set the houses back from the street.

# The Legacy of the Sunderland Cottage

Cottages have been a fixture of Sunderland's townscape for over a century and a half, but in that time their form, status and ownership has changed considerably. The practice of altering cottages began earlier than might be expected, indeed almost as soon as the houses were completed. The most common alteration was to convert the attic into an extra bedroom, which involved inserting a staircase or simply a ladder into a ground floor room. Converting the attic meant that dormer windows were often inserted into the roof space and this disrupted the unity of the serried ranks of terraced streets [Figs. 60–62]. By the 1920s, backyards were being remodelled to incorporate garages for cars. Clearly, the Sunderland cottage was a highly adaptable form of housing [Fig. 63].

The legacy of the Sunderland cottage is problematic for modern homeowners and conservationists alike. This was never more evident than in the 1960s and early 1970s. As traditional industries declined and Britain moved towards an information and service-based economy, Victorian terraced housing sometimes came to be viewed as a grim relic of the industrial past.[1] Acres of Britain's nineteenth century townscapes were swept away in the name of slum-clearance and alternative forms of housing, including tower blocks, began to rise in their place.

Between 1968 and 1975, Sunderland Corporation conducted a programme of slum clearances in the Millfield area, against the wishes of most of the resident population [Fig. 64]. The *Sunderland Echo* printed numerous letters of protest from Millfield residents. One respondent wrote, 'Housing today is a social evil because families are turned out of their cherished cottages in miss-named "slum-clearance" schemes.'[2] Questioning the Council's preference for high-rise flats, an interviewer was told that 'high-rise blocks are essential to the skyline of the town,' an indication that planners were committed to industrialised building systems and Modernist aesthetics as a means of boosting Sunderland's profile. Tower blocks and low-rise dwellings were built as public housing in various parts of the town during the 1960s. Demolition of cottages proceeded, despite the fact that 64 per cent of residents claimed to be satisfied with the structural condition of their home.[3]

Norman Dennis, a sociologist based at Newcastle University, studied the clearances in his book *People and Planning: the Sociology of Housing in*

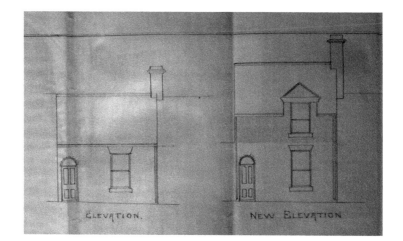

Fig. 60: Plans for a dormer extension in Cirencester Street. TWAS – 269/1213.

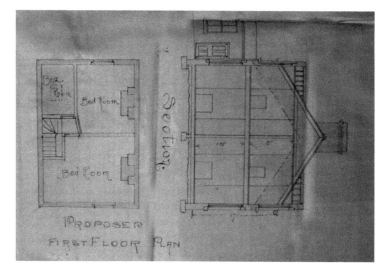

Fig. 61: Plans for a dormer extension in Cirencester Street. TWAS – 269/1213.

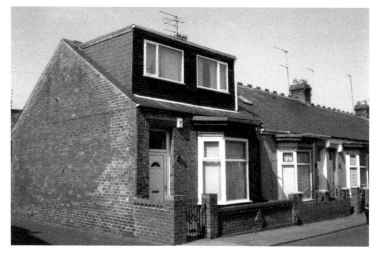

Fig. 62: Dormer extension in Dene Street, Pallion.

Fig. 63: Backyard
converted for car-storage in
Barnard Street, High Barnes.

Fig. 64: Hedley Street
in Millfield, which was
demolished as part of
the slum clearances. ©
Sunderland Antiquarian
Society.

*Sunderland* (1970). Dennis was born in Booth Street, Millfield in 1929 [Fig. 65].
During the time of the controversy he lived in Rosslyn Terrace, a street of two-
storey houses immediately south of Rosslyn Street. As a Senior Research Fellow
at Durham University, Dennis had previously been in charge of a team studying
Sunderland's housing needs, and concluded that cottages continued to offer
comfortable, affordable housing. Dennis opposed the clearances and voiced the
objections of local residents who regarded their dwellings as satisfactory. He was
aided by the Revd James Taylor, vicar of St Mark's Church, Millfield, who acted as
a focus for the opposition.

   It is important to realise that Millfield residents were not opposed to cottage-
clearance per se; they simply wanted to know that the new housing would be
superior to the old. As Dennis remarked, 'It is bad mistake to think that the
Millfielders were against slum clearance. They were against being offered
something worse than they possessed. Millfielders who wanted to move from
poor accommodation were fully supported in their thoroughly sensible wishes by
their neighbours, and poor streets were fully acknowledged as poor streets that
ought to be demolished.'[4] To Dennis, a central flaw in the planning department's
methodology was the lack of meaningful consultation with local residents [Fig.

Fig. 65: Booth Street in Millfield, where cottage-supporter Norman Dennis was born in 1929.

66]. Dennis was of the opinion that residents were able to distinguish between genuine slums and houses that were still fit for purpose, but that these views were routinely dismissed by planners: 'Millfielders were perfectly capable of recognising a better car or a better washing machine or a better bargain in groceries, given the totality of their own circumstances. Within the planners' and architects' *Weltanschauung* these able people weren't supposed to be able to tell what were, for them, better or worse housing conditions.'[5]

It is debatable whether residents could, in fact, differentiate between slums and fit-for-purpose housing. Sanitary and health issues are the subject of informed professional judgement. Sunderland Council had what was probably the best database of any local authority, in that every pre-1914 house had been inspected and graded according to the facilities within the property and its structural condition. Thus, the condition of older housing was continuously monitored. It is undeniable that much of the housing in question was sub-standard. Residents; however, were probably used to living in the conditions prevailing in these homes, and because most properties were owner-occupied there was an understandable reluctance on the residents' part to give them up. It is likely that residents were satisfied with their housing, but unaware of how sub-standard it actually was [Fig. 67].

The Council had a statutory duty to seek improvements to the housing stock where it fell below desired standards, so the issue becomes one of how far a paternalistic state should be allowed to intervene in people's lives if they are satisfied with their lot. The worst areas were the remit of Public Health Inspectors, who evaluated the condition of properties. There would be little doubt that the properties included in any given clearance area would be mainly slums. Any Clearance Area and Compulsory Purchase Order would be subject to a public inquiry presided over by an independent professional Inspector, who would evaluate the Council's case before making a recommendation to Central Government as to whether it was appropriate to proceed with the clearance. Consequently, in the main, property was probably rightly classed as unfit by the prevailing national standards and the perception that property was erroneously classed as slums was probably not valid.

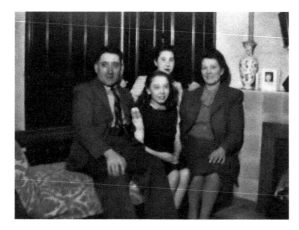

Fig. 66: Pig farmer and pork butcher John Kirtlan with his family at No. 10 Burnaby Street, Millfield in the 1950s. © Norman Kirtlan.

Fig. 67: Dilapidated cottages in Hedley Street, Millfield. © Sunderland Antiquarian Society.

If we accept that the homes within the clearances were indeed substandard, the question remains of whether an alternative to demolition could have been found. Sunderland's older housing policy at the time was based on an assumption that all older housing would require clearance at some time in the future and that those houses deemed unfit by professional Public Health Inspectors should be cleared in the short term. Other poor areas were denied grant assistance, which potentially pushed them towards being slums, since no public assistance was made available to fund improvements. Slightly better areas, where it was unlikely that clearance could take place within fifteen years were eligible for 'standard grants' for basic facilities, while the best areas were eligible for full 'discretionary grants', which made funds available for more substantial repairs and installation of basic facilities.

Having identified an area of unfit housing, the Council, instead of clearing them, could in theory have adopted a policy of comprehensive improvement. Some local authorities, such as Newcastle and Rochdale, were experimenting with this approach. However, it was innovative and very resource intensive in terms of both staff and money. Most authorities were adopting the clearance approach to unfit

housing in the same way as Sunderland. Ultimately, improvement of the existing stock came to be seen nationally as less damaging to established communities than outright demolition, but it took time for its effectiveness and desirability to be appreciated. A national rethink of approaches to dealing with sub-standard housing, based on experiments such as those in Newcastle and Rochdale, led to the Housing Act of 1974, which enabled Councils to declare the poorest areas as 'Housing Action Areas' (HAAs), and high levels of grant were made available to improve property.

The Millfield saga arguably changed the attitude of Sunderland Council and was part of the wider change in perspectives toward clearance policies in general. Norman Dennis's publications exposed the shallow nature of resident consultation within the clearance programme. His landmark study *Public Participation and Planners' Blight* (1972) was a vehement critique of the planning bureaucracy's reluctance to listen to residents.[6] As an educated advocate with close links to Millfield residents, Dennis was instrumental in transforming the public perception of Sunderland cottages, which came to be known as 'little palaces' [Fig. 68]. As this attitude gathered popular support, Sunderland Council adopted a 'retain and refurbish' policy using grant aid delivered by the Housing Act and declared a number of HAAs in various parts of the town, including Millfield and Southwick.

Adaptation

Today, cottages still form an integral part of Sunderland's housing stock and are particularly popular with first-time buyers. However, the ownership of cottages now spans a much wider social spectrum than it did originally. With higher levels of affluence, lower-middle class owners can afford to remodel their houses more extensively. In recent years, individual householder activity has resulted in many dormer extensions in roof spaces in order to maximise capacity [Fig. 69]. However, many of these alterations are regrettable from an aesthetic point of view.

Some cottages have been given new frontages, giving the impression that they have been entirely rebuilt [Figs. 70 and 71]. Numerous cottages have been covered with pebbledash or render, obscuring the original decorative features and brickwork. Rendering can have a long term effect as it is expensive and difficult to remove without damaging the historic brick. Both Martin Terrace and Dene Street in Pallion have attractive decorative tiles set into the woodwork, but in many cases these have been painted over [Figs. 72 and 73]. The original Welsh slate roof tiles have often been replaced with synthetic products such as Eternit, and the original sash-style windows have given way to modern substitutes. Many cottages have had replacement doors and windows fitted, often in garish uPVC. These alterations fall within the home owners' permitted development rights, but frequently result in a significant alteration to the character of the front elevations. Consequently, it is virtually impossible to find a cottage street in its original state.

Fig. 68: Superior cottages in
Guisborough Terrace, High Barnes.

Fig. 69: Box dormers added
to a cottage in Carnegie Street,
Grangetown.

However, it could be argued that the adaptability of the Sunderland cottage is one
of its strengths and a major factor in its enduring popularity. Adaptations have
become part of the 'popular culture' of the cottages and can be regarded as an
attempt to personalise one's dwelling.

## Conservation

Sunderland is renowned for its distinctive single-storey terraced housing,
and there is a strong case for conserving the best remaining examples. It is
important that we recognise the significance of the cottage form in Sunderland's
nineteenth- and twentieth-century urban growth, and its place within the
city's industrial, social and architectural heritage. At present, only two cottage
streets have been listed as buildings of special architectural or historical
interest: Ridley Terrace in Hendon and James Armitage Street in Southwick.
It is hoped that Sunderland City Council will designate a number of cottage
streets as Conservation Areas, which will help to safeguard a valuable aspect
of Sunderland's built heritage [Fig. 74].

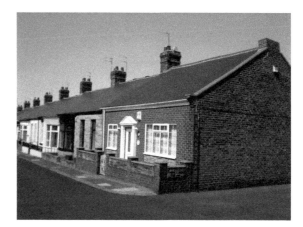

Fig. 70: New brick frontage and uPVC door surround added to a cottage in Dunbar Street, High Barnes.

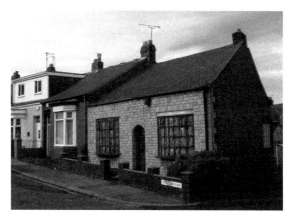

Fig. 71: Cottage in Cedric Crescent, Barnes with modern stone cladding and bow windows to 'personalise' the frontage.

Among the best preserved examples are those in the High Barnes estate, particularly the ABC streets, where superior design and larger capacity has meant that alterations have rarely been necessary. As at High Barnes, the development of cottages in Roker and Fulwell was closely linked to the introduction of the tram, allowing people to live further away from the centres of industry. This area has some of the best examples of later Sunderland cottages, with many remaining unaltered, particularly those that run alongside the metro line. The streets around Queen's Crescent have very good examples of cottages of their time; an attractive characteristic of these streets is that many retain corner-shops on the end of the row, which captures some of the original layout. Elsewhere, Hazeldene Terrace and Mafeking Street in Pallion have unspoiled examples of basic cottages and are good candidates for conservation. Rosslyn Street is atypical in many respects, but it has survived largely unaltered and is remarkable for its high standard of design.

Sunderland City Council's Conservation Team has investigated the possibility of designating several discrete areas of Sunderland cottages under the umbrella of one 'Sunderland Cottage Conservation Area'. This is an unusual approach, but one that seems more appropriate than declaring separate Conservation Areas of similar architectural character. This option would introduce a degree of protection

Fig. 72: Cottage with decorative tiles at Martin Terrace, Pallion.

Fig. 73: Detail of decorative tiles at Martin Terrace, Pallion. In many neighbouring cottages, these tiles have unaccountably been painted over.

for an important aspect of the city's architectural heritage. Designating areas in different parts of the city would help to preserve a record of the various stages in the history of cottages.

One possibility is to impose strict controls following the usual Conservation Area management approach. However, this approach generally carries an assumption to preserve original features, and strict controls such as these are unlikely to be popular with residents. According to English Heritage, 'Change is inevitable in most Conservation Areas; the challenge is to manage change in ways that maintain and, if possible, reinforce an area's special qualities. The character of conservation areas is rarely static and is susceptible to incremental, as well as dramatic, change.'[7]

A second option suggested by the Council's conversation team is to take a more flexible, 'pop culture' approach without imposing the usual Conservation Area restrictions. Issues with this option include potential difficulties in developing an enforcement strategy, consistency of decision making, monitoring change, and availability of resources for management. By adopting this more

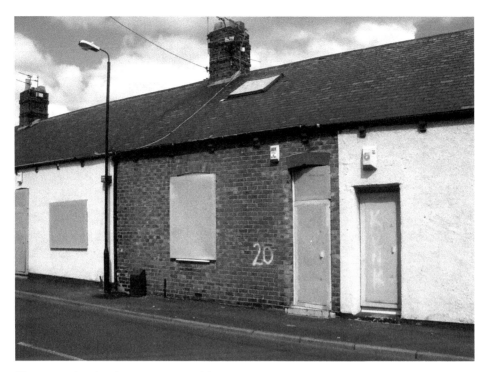

Fig. 74: Dilapidated cottage in Oswald Terrace West, Castletown.

flexible approach, the Conservation team would in theory work with residents to develop an appropriate and tailor-made management plan for each area. This would hopefully reduce the number of insensitive cottage alterations and encourage the use of more appropriate replacement windows and doors etc. Ultimately, this would help to protect and enhance areas of Sunderland cottages for the benefit of existing and future residents. If residents retained their permitted development rights, however, those who dissented from the overall management plan would inevitably go their own way, in similar fashion to what has been happening over the last thirty or forty years. The effect would probably be a patchwork quilt of conservation. The concept thus needs further development before its practicality can be established, but a Conservation Area Management Strategy based on more community involvement would be a good thing, as it would better reflect residents' values.

# Conclusion

The Sunderland cottage is now recognised as a distinctive housing form and an innovative late nineteenth and early twentieth-century solution to the perennial problem of housing Britain's working classes. There is much debate about where the form came from and why it was adopted so readily in Sunderland and rarely anywhere else, but it is a form that has satisfied housing needs up to the present day.[1]

In the 1840s Sunderland was rapidly developing into a major industrial town, with workers and their families tending to live close to the docks, shipyards and coalmines; often in dilapidated, unsanitary and overcrowded dwellings. In common with most industrial towns, Sunderland launched into a flurry of building activity to fulfil the dire need for housing. However, the workers' housing built in Sunderland was exceptional. Rows of terraced bungalows are virtually unique to Sunderland, sharing characteristics of the Durham pit row, rather than the workers' dwellings of other industrial areas.

The temporal and spatial evolution of cottages illustrates different phases in Sunderland's development in response to the needs of its industries and people. Cottages developed in various parts of the town according to specific physical and social factors. The earliest examples clustered around industrial sites such as Monkwearmouth Colliery, Hartley's glassworks and the shipyards. Most of these developments were instigated by private builders who recognised the demand for housing close to industrial sites. Later cottages occurred in High Barnes, Fulwell, Seaburn and Roker, as transport improvements made it possible to live further from the workplace.

The majority of Sunderland cottages were built by speculative builders eager to capitalise on the town's dramatic industrial expansion and the resulting demand for housing. Significantly, some of the best local architects of the day were involved in their design, including Sunderland's foremost architects William and Thomas Ridley Milburn, who designed the Empire Theatre as well as the ABC streets in High Barnes. Estates were planned by architects following a gridiron layout, but individual terraces were built up in a sporadic manner depending on who owned the land or chose to develop it.

Derived from pit row housing and agricultural cottages, the Sunderland cottage can be seen as a transitional form between vernacular building and polite architecture. Variations in cottage design can be seen within specific areas. As the cottages became increasingly popular, and the population increasingly affluent, new cottages were more likely to be double-fronted as opposed to the original single-fronted properties. Cottage ornament followed standard economical designs found in pattern books and commercial catalogues, while internal fittings sometimes derived added quality from local shipbuilding skills.

Owing to the difficulties of researching the form, cottages have hitherto evaded easy analysis and attribution. This study has shown, however, that most of the cottages were designed by Sunderland's professional architects and that they formed an integral part of the architects' practice. The Sunderland cottage can now be extracted from the obscure category of 'vernacular' architecture and viewed as the product of concerted and mutually-beneficial interaction between Sunderland's building trade and its emerging architectural profession, an interaction which helped to raise living standards for the hardworking people of Sunderland.

The Sunderland cottage gave a sector of the working class access to a middle class level of security, social mobility and choice. This ingenious form is a testament to the relative prosperity of the skilled artisans who worked in Sunderland's shipyards. Crucially, each had its own entrance and backyard, and some had private gardens. Many of the occupiers were also owners of the property due to the activities of small building societies who sponsored the building of small estates for well-paid shipyard workers. As the exceptionally high levels of owner-

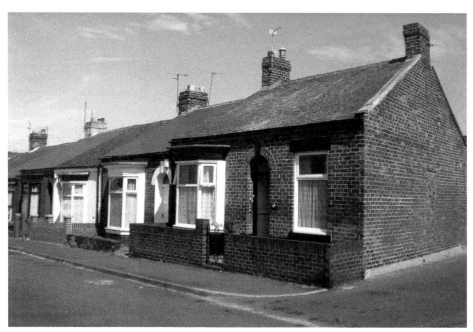

Fig. 75: Double-fronted cottages in Hendon Valley Road, Hendon.

occupancy suggest, cottages were a major source of pride to their inhabitants. The geography of cottages broadly followed the social divisions of the town, but each cottage was a minute bastion of privacy that conveyed ideals of respectable domesticity and allowed residents to accumulate social status [Fig. 75].

Even today, cottages represent the backbone of working-class communities across the city. Ranks of single-storey terraces continue to dominate Sunderland's built environment and remain integral to its cultural identity. Their popularity within today's housing market confirms the Sunderland cottage as a durable component of the city's residential sector. Arguably, the character of Sunderland cottages has changed over time from traditional working class and skilled artisan housing to a broader mix of occupants and tenancies. The enduring popularity of the cottage and the unique adaptability of the form have led to numerous householder alterations, some to make larger living spaces, others to 'personalise' the appearance of homes. Many of these alterations have a negative impact on the streetscape and drastically alter the historic character of properties, but such alterations have nonetheless become a fundamental part of the character of the houses. This raises implications for the conservation of cottages. It is hoped that some of the best surviving examples will be protected from excessive redevelopment in order to conserve a valuable aspect of Sunderland's architectural heritage.

# Appendix

The following section presents a survey of cottage-building activity in Sunderland between *c.* 1865 and 1934. The information has been gathered from the extensive collection of Sunderland street plans preserved in the Tyne and Wear Archives. At present, these have not been fully catalogued and are indexed according to an interim list. The spreadsheet gives the number of cottages proposed to be built, together with the street name, location, and names of the builder and architect. In each case, the date is given as the day on which the plan was received by the local authority, as this is the date that has been recorded most consistently. Building operations have been arranged alphabetically by street name, then chronologically. Unfortunately, the survey cannot be definitive, since plans have not survived for every street.

## Abingdon Street, High Barnes

| Builder | Architect | No. of cottages | Date | TWAS Ref. |
| --- | --- | --- | --- | --- |
| John Parker | W. and T. R. Milburn | 6 | 25 Jan 1898 | 269/1 |
| John Emmerson and Son | W. and T. R. Milburn | 6 | 25 Jan 1898 | 269/2 |
| Bell and Parker | W. and T. R. Milburn | 6 | 22 Feb 1898 | 269/3 |
| Thomas Humphrey | W. and T. R. Milburn | 6 | 22 Feb 1898 | 269/4 |
| John Emmerson and Son | W. and T. R. Milburn | 6 | 22 Feb 1898 | 269/5 |
| Thomas Humphrey | W. and T. R. Milburn | 6 | 22 Feb 1898 | 269/6 |
| William Leithes | W. and T. R. Milburn | 4 | 30 Aug 1898 | 269/7 |
| Robert Hudson | W. and T. R. Milburn | 4 | 25 Apr 1899 | 269/8 |
| J. B. Shilling | W. and T. R. Milburn | 2 | 30 Jan 1900 | 269/9 |

## Ancona Street, Pallion

| Builder | Architect | No. of cottages | Date | TWAS Ref. |
| --- | --- | --- | --- | --- |
| Christopher Jacques | Unknown | 4 | 19 Mar 1880 | 269/92 |
| Christopher Jacques | Unknown | 2 | 13 Aug 1881 | 269/93 |
| Christopher Jacques | Unknown | ? | 29 Sep 1882 | 269/95 |
| Christopher Jacques | Unknown | 3 | 9 Dec 1882 | 269/94 |
| Christopher Jacques | Unknown | 4 | 25 May 1883 | 269/96 |

| T. H. Dunwoodie | T. R. Milburn | 8 | 7 Nov 1895 | 269/99 |
| T. H. Dunwoodie | W. and T. R. Milburn | 9 | 27 Jul 1896 | 269/100 |
| Robert Hudson | S. D. Robbins | 8 | 3 Nov 1902 | 269/101 |
| R. Towns and Sons | S. D. Robbins | 2 | 28 Aug 1903 | 269/102 |
| R. P. Hudson | Robins and Wilson | 2 | 28 Nov 1905 | 269/103 |
| R. P. Hudson | Robins and Wilson | 4 | 28 Feb 1906 | 269/104 |
| R. P. Hudson | Rowland Wilson | 7 | 27 Nov 1906 | 269/105 |

## Arlington Street, Pallion

| Builder | Architect | No. of cottages | Date | TWAS Ref. |
| --- | --- | --- | --- | --- |
| Sunderland Equitable Building Society | W. and T. R. Milburn | 15 | 30 May 1899 | 269/133 |

## Atkinson Road, Millfield

| Builder | Architect | No. of cottages | Date | TWAS Ref. |
| --- | --- | --- | --- | --- |
| W. Purvis | Unknown | 4 | Unknown | 269/269 |
| W. Purvis | Unknown | 12 | 1 Sep 1931 | 269/273 |

## Barnard Street, High Barnes

| Builder | Architect | No. of cottages | Date | TWAS Ref. |
| --- | --- | --- | --- | --- |
| J. W. White | W. and T. R. Milburn | 24 | 17 Nov 1898 | 269/360 |
| J. W. White | W. and T. R. Milburn | 24 | 17 Nov 1898 | 269/361 |
| J. Leithes | W. and T. R. Milburn | 1 | 24 Mar 1900 | 269/362 |

## Blackett Terrace, Millfield

| Builder | Architect | No. of cottages | Date | TWAS Ref. |
| --- | --- | --- | --- | --- |
| William Hunter | John Eltringham | 4 | 10 Jan 1889 | 269/545 |
| William Hunter | John Eltringham | 4 | 5 Sep 1889 | 269/546 |
| William M. Skinner | John Eltringham | 3 | 14 Nov 1889 | 269/547 |
| William M. Skinner | John Eltringham | 4 | 10 Feb 1890 | 269/548 |
| William Hunter | John Eltringham | 5 | 15 May 1890 | 269/550 |

## Brady Street, Pallion

| Builder | Architect | No. of cottages | Date | TWAS Ref. |
| --- | --- | --- | --- | --- |
| William Parkinson | G. A. Middlemiss | 2 | 25 Apr 1884 | 269/635 |
| William Thompson | Middlemiss and Green | 4 | 31 Jul 1884 | 269/636 |
| John Jones | Unknown | 2 | 27 Feb 1885 | 269/637 |
| J. L. Howarth | W. and T. R. Milburn | 7 | 29 Aug 1899 | 269/638 |
| J. L. Howarth | W. and T. R. Milburn | 6 | 29 Aug 1899 | 269/639 |
| M. McGlynn | W. and T. R. Milburn | 17 | 13 Jun 1923 | 269/641 |
| M. McGlynn | W. and T. R. Milburn | 17 | 13 Jun 1923 | 269/642 |

## Bright Street, Monkwearmouth

| Builder | Architect | No. of cottages | Date | TWAS Ref. |
| --- | --- | --- | --- | --- |
| George Davison | Joseph Potts and Son | 2 | 29 Aug 1884 | 269/730 |
| George Davison | Joseph Potts and Son | 2 | 17 Jul 1885 | 269/732 |
| George Davison | Joseph Potts and Son | 2 | 27 Dec 1888 | 269/734 |
| Charles Gibson and J. Hall | Unknown | 4 | 5 Feb 1891 | 269/736 |
| Charles Gibson | Unknown | 2 | 18 Aug 1892 | 269/737 |
| Frank H. Storey | Joseph Potts and Son | 2 | 29 Sep 1892 | 269/749 |
| Arthur E. Stephenson | Unknown | 4 | 8 Dec 1892 | 269/738 |
| Arthur E. Stephenson | Unknown | 2 | 31 Aug 1893 | 269/741 |
| R. F. Bearpark | Unknown | 2 | 24 Mar 1896 | 269/746 |
| Frank H. Storey | Joseph Potts and Son | 6 | 26 Jan 1897 | 269/748 |
| George Swan | Joseph Potts and Son | 2 | 10 Dec 1897 | 269/750 |

## Brinkburn Street, Millfield

| Builder | Architect | No. of cottages | Date | TWAS Ref. |
| --- | --- | --- | --- | --- |
| J. C. Stamp | W. and T. R. Milburn | 2 | 25 Feb 1896 | 269/753 |
| John McMahone | William Milburn | 2 | 21 Mar 1896 | 269/754 |
| J. Parker | William Milburn | 2 | 24 Mar 1896 | 269/755 |
| Woodhill and Kirtley | William Milburn | 2 | 28 Apr 1896 | 269/758 |
| J. Parker | William Milburn | 2 | 28 Apr 1896 | 269/756 |
| William Greenwell | William Milburn | 2 | 28 Apr 1896 | 269/757 |
| Monte and Willis | William Milburn | 2 | 26 May 1896 | 269/759 |

## Broadsheath Terrace, Southwick

| Builder | Architect | No. of cottages | Date | TWAS Ref. |
| --- | --- | --- | --- | --- |
| William Johnson | Joseph Spain | 2 | 4 Oct 1901 | 269/761 |
| John Hugill | Joseph Spain | 6 | 10 Feb 1902 | 269/762 |
| J. C. Hodge | Joseph Spain | 7 | 28 May 1903 | 269/763 |
| W. C. Craggs | Joseph Spain | 1 | 12 Sep 1903 | 269/767 |
| William Whitfield | Joseph Spain | 2 | 30 Sep 1903 | 269/764 |
| John Whitfield Junior | Joseph Spain | 2 | 30 Sep 1903 | 269/765 |
| John Whitfield Junior | Joseph Spain | 2 | 30 Sep 1903 | 269/766 |
| Joseph W. Whitfield | Joseph Spain | 3 | 10 Oct 1903 | 269/768 |
| Joseph W. Whitfield | Joseph Spain | 1 | 10 Feb 1904 | 269/773 |
| T. S. Thompson | Joseph Spain | 1 | 17 Jun 1904 | 269/771 |
| T. S. Thompson | Joseph Spain | 2 | 21 Jul 1904 | 269/770 |
| T. S. Thompson | Joseph Spain | 4 | 23 Sep 1904 | 269/775 |
| T. S. Thompson | Joseph Spain | 6 | 19 Oct 1904 | 269/772 |
| T. S. Thompson | Joseph Spain | 1 | 8 Feb 1905 | 269/776 |
| W. Davis | Joseph Spain | 1 | 18 Feb 1905 | 269/782 |
| W. Purvis | Joseph Spain | 1 | 13 Apr 1905 | 269/778 |
| A. Morallee | Joseph Spain | 1 | 3 May 1905 | 269/779 |

| W. J. Stephenson | Joseph Spain | 6 | 15 Jun 1905 | 269/781 |
| T. S. Thompson | Joseph Spain | 2 | 19 Dec 1905 | 269/783 |
| W. J. Stephenson | Joseph Spain | 6 | 15 Jan 1906 | 269/786 |
| J. Naylor | Joseph Spain | 2 | 12 Jul 1906 | 269/785 |
| Mary Foster | Joseph Spain | 2 | 18 Sep 1906 | 269/784 |
| M. Napier | Joseph Spain | 2 | 9 May 1907 | 269/789 |
| William Johnson | Joseph Spain | 2 | 20 Nov 1907 | 269/788 |
| Unknown | W. and T. R. Milburn | 17 | 17 Jul 1934 | 269/795 |

## Brookland Road, High Barnes

| Builder | Architect | No. of cottages | Date | TWAS Ref. |
|---|---|---|---|---|
| Thomas E. Hall | Unknown | 3 | 12 Jun 1884 | 269/822 |
| Thomas E. Hall | Unknown | 3 | 12 Jun 1884 | 269/823 |
| J. W. Booth, J. Bainbridge, Titus Sutcliffe | Unknown | 3 | 21 Jun 1884 | 269/821 |
| J. Bainbridge | Unknown | 1 | 21 Jan 1885 | 269/820 |
| J. R. Addison and George Ditchfield | T. R. Milburn | 12 | 17 Mar 1885 | 269/824 |
| J. R. Addison and George Ditchfield | T. R. Milburn | 9 | 29 May 1885 | 269/825 |

## Brunton Terrace, Millfield

| Builder | Architect | No. of cottages | Date | TWAS Ref. |
|---|---|---|---|---|
| John Greenwell | T. R. Milburn | 2 | 24 May 1894 | 269/836 |
| John Elrick | John Eltringham | 9 | 7 Jun 1894 | 269/837 |
| W. B. Cooper | T. R. Milburn | 7 | 1 Aug 1894 | 269/838 |
| W. B. Cooper | T. R. Milburn | 1 | 28 Jan 1896 | 269/839 |

## Burnaby Street, Millfield

| Builder | Architect | No. of cottages | Date | TWAS Ref. |
|---|---|---|---|---|
| Unknown | William Milburn | 2 | 22 Aug 1889 | 269/861 |

## Cairo Street, Hendon

| Builder | Architect | No. of cottages | Date | TWAS Ref. |
|---|---|---|---|---|
| Wearmouth Coal Company | H. E. Robinson | 24 | 28 Aug 1900 | 269/922 |
| R. F. Smith | H. E. Robinson | 6 | 23 Apr 1901 | 269/898 |
| J. and T. Parker | H. E. Robinson | 6 | 29 May 1901 | 269/920 |
| J. and T. Parker | H. E. Robinson | 6 | 27 Aug 1901 | 269/918 |
| J. and T. Parker | H. E. Robinson | 7 | 29 Oct 1901 | 269/917 |
| R. F. Smith | H. E. Robinson | 3 | 12 Dec 1901 | 269/916 |
| James Briggs | H. E. Robinson | 6 | 27 Oct 1903 | 269/910 |
| R. F. Smith | H. E. Robinson | 6 | 28 Oct 1903 | 269/923 |
| J. M. Gibbons | H. E. Robinson | 7 | 23 Feb 1904 | 269/906 |
| J. Richmond | H. E. Robinson | 5 | 24 Mar 1904 | 269/915 |

| | | | | |
|---|---|---|---|---|
| Hedley Ransome | H. E. Robinson | 2 | 25 Apr 1904 | 269/921 |
| J. and T. Parker | H. E. Robinson | 10 | 28 Jun 1904 | 269/914 |
| J. M. Gibbons | H. E. Robinson | 6 | 30 Aug 1904 | 269/913 |
| J. M. Gibbons | H. E. Robinson | 6 | 28 Mar 1905 | 269/912 |
| J. M. Gibbons | H. E. Robinson | 6 | 29 Aug 1905 | 269/911 |
| J. M. Gibbons | H. E. Robinson | 4 | 27 Feb 1906 | 269/909 |

## Canon Cockin Street, Hendon

| Builder | Architect | No. of cottages | Date | TWAS Ref. |
|---|---|---|---|---|
| George Patterson | Middlemiss and Green | 4 | 26 Sep 1884 | 269/946 |
| G. and J. M. Gibbons | Middlemiss and Green | 11 | 26 Sep 1884 | 269/947 |
| Edward Rangely | Middlemiss and Green | 4 | 8 Oct 1884 | 269/945 |
| John Allan | Middlemiss and Green | 3 | 9 Dec 1884 | 269/944 |
| R. C. Green | Unknown | 19 | 21 Feb 1899 | 269/943 |
| Joseph Huntley | J. W. Chapman | 6 | 4 Nov 1901 | 269/942 |
| Wearmouth Coal Company | H. E. Robinson | 27 | 26 Nov 1901 | 269/940 |
| Wearmouth Coal Company | H. E. Robinson | 28 | 14 Dec 1901 | 269/941 |
| J. and T. Parker | J. W. Chapman | 1 | 26 Jun 1903 | 269/939 |
| Bailes and Son | H. E. Robinson | 14 | 30 May 1905 | 269/938 |
| R. Burlinson | H. E. Robinson | 4 | 18 Jan 1906 | 269/962 |
| T. Golding | H. E. Robinson | 2 | 21 Apr 1906 | 269/959 |
| C. Hope | H. E. Robinson | 2 | 21 Apr 1906 | 269/963 |
| T. Golding | H. E. Robinson | 2 | 21 Sep 1906 | 269/958 |
| J. M. Gibbons and Son | H. E. Robinson | 6 | 23 Apr 1907 | 269/957 |
| C. Hope | H. E. Robinson | 2 | 25 Jun 1907 | 269/956 |
| C. Hope | H. E. Robinson | 2 | 17 Oct 1907 | 269/960 |
| J. M. Gibbons and Son | H. E. Robinson | 2 | 28 Jan 1908 | 269/955 |
| J. M. Gibbons and Son | H. E. Robinson | 2 | 28 Apr 1908 | 269/954 |
| J. M. Gibbons and Son | H. E. Robinson | 4 | 30 Sep 1908 | 269/953 |
| J. M. Gibbons and Son | H. E. Robinson | 1 | 30 Jun 1909 | 269/952 |
| T. Golding | H. E. Robinson | 1 | 27 Jul 1909 | 269/961 |
| J. M. Gibbons and Son | H. E. Robinson | 1 | 28 Aug 1909 | 269/951 |
| J. M. Gibbons and Son | H. E. Robinson | 2 | 25 Jan 1910 | 269/950 |
| J. M. Gibbons and Son | H. E. Robinson | 6 | 13 Jun 1923 | 269/949 |

## Chester Terrace, Pallion

| Builder | Architect | No. of cottages | Date | TWAS Ref. |
|---|---|---|---|---|
| John Tulip | William Milburn | 12 | 25 Mar 1886 | 269/1170 |
| John Tulip | William Milburn | 12 | 7 Oct 1886 | 269/1169 |

## Close Street, Millfield

| Builder | Architect | No. of cottages | Date | TWAS Ref. |
|---|---|---|---|---|
| William Scott | W. and T. R. Milburn | 10 | 29 Sep 1897 | 269/1346 |

## Co-operative Terrace, Millfield

| Builder | Architect | No. of cottages | Date | TWAS Ref. |
|---|---|---|---|---|
| Sunderland Equitable Building Society | William Milburn | 14 | 12 Apr 1892 | 269/1390 |

## Cornhill Road, Southwick

| Builder | Architect | No. of cottages | Date | TWAS Ref. |
|---|---|---|---|---|
| W. T. Jupp | Joseph Potts and Son | 2 | 24 Dec 1908 | 269/1416 |
| Unknown | Joseph Potts and Son | 2 | 22 Mar 1909 | 269/1415 |

## Cromwell Street, Millfield

| Builder | Architect | No. of cottages | Date | TWAS Ref. |
|---|---|---|---|---|
| George Gilmore Walker | Joseph Potts and Son | 3 | 13 Dec 1871 | 269/1467 |
| John Hudson | Unknown | 2 | 23 Feb 1877 | 269/1463 |

## Dene Street, Pallion

| Builder | Architect | No. of cottages | Date | TWAS Ref. |
|---|---|---|---|---|
| John Young | Unknown | 4 | 13 Oct 1892 | 269/1584 |
| John Young | Unknown | 2 | 13 Oct 1892 | 269/1585 |
| John Young | Unknown | 4 | 10 Nov 1892 | 269/1586 |
| John Young | Unknown | 1 | 8 Mar 1893 | 269/1587 |
| George Wanless | William Milburn | 6 | 15 Aug 1895 | 269/1588 |
| William Dixon | William Milburn | 4 | 15 Aug 1895 | 269/1589 |
| William Dixon | William Milburn | 4 | 10 Oct 1895 | 269/1590 |
| W. G. Browell | William Milburn | 7 | 28 Jan 1896 | 269/1591 |

## Devonshire Street, Monkwearmouth

| Builder | Architect | No. of cottages | Date | TWAS Ref. |
|---|---|---|---|---|
| J. M. Wayman | Unknown | 10 | 10 Jan 1865 | 269/1615 |
| Joseph Tyers | John Tillman | 4 | 21 Jun 1865 | 269/1667 |
| J. M. Wayman | Unknown | 4 | 14 Jul 1865 | 269/1664 |
| George Gray | Thomas Tillman | 1 | 11 Aug 1865 | 269/1666 |
| Mr. Shaftoe | John Shadforth | 1 | 25 Aug 1865 | 269/1668 |
| Unknown | John Shadforth | 2 | 22 Sep 1865 | 269/1670 |
| John Young | John Shadforth | 2 | 22 Sep 1865 | 269/1669 |
| Joseph Tyers | Unknown | 6 | 6 Mar 1866 | 269/1672 |
| Joseph Tyers | Unknown | 5 | 6 Mar 1866 | 269/1673 |
| John Young | Unknown | 2 | 20 Apr 1866 | 269/1674 |
| Joseph Tyers | Unknown | 5 | 4 May 1866 | 269/1671 |
| John Young | Unknown | 4 | 4 May 1866 | 269/1678 |
| Thomas Fairley | J. Tillman | 2 | 15 Oct 1869 | 269/1677 |
| Unknown | John Shadforth | 2 | 24 Jan 1870 | 269/1675 |
| John Young | Unknown | 4 | 25 Nov 1870 | 269/1679 |

| Ralph Howe | Unknown | 1 | 21 Jul 1871 | 269/1680 |
|---|---|---|---|---|
| Thomas Fairley | Unknown | 2 | 1 Oct 1871 | 269/1685 |
| William Blakey | Unknown | 2 | 4 Jan 1873 | 269/1682 |
| William Blakey | Unknown | 2 | 26 May 1873 | 269/1681 |
| John Crallan | Unknown | 1 | 31 Feb 1874 | 269/1659 |
| Unknown | Henry Woodhill | 3 | 1 Aug 1874 | 269/1660 |
| William Blakey | Henry Woodhill | 1 | 1 Aug 1874 | 269/1662 |
| George Rowland | Unknown | 2 | 31 Aug 1874 | 269/1650 |
| John Brown | Unknown | 1 | 26 Sep 1874 | 269/1652 |
| John Crallan | Unknown | 1 | 12 Oct 1874 | 269/1653 |
| George Harland | Unknown | 2 | 9 Nov 1874 | 269/1654 |
| George Rowland | J. and T. Tillman | 1 | 18 Jan 1875 | 269/1658 |
| George Rowland | Unknown | 2 | 12 Apr 1875 | 269/1648 |
| Thomas Newby | J. and T. Tillman | 2 | 8 May 1875 | 269/1646 |
| Thomas Spain | J. and T. Tillman | 2 | 8 May 1875 | 269/1647 |
| Thomas Newby | J. and T. Tillman | 2 | 23 Oct 1875 | 269/1645 |
| William Blakey | J. and T. Tillman | 4 | 29 Jan 1876 | 269/1642 |
| Thomas Davison | Unknown | 2 | 29 Jan 1876 | 269/1643 |
| John Ridley | Unknown | 4 | 29 Jan 1876 | 269/1644 |
| Thomas Fairley | Unknown | 1 | 21 Feb 1876 | 269/1636 |
| Thomas Fairley | Unknown | 2 | 10 Dec 1876 | 269/1676 |

## Eastfield Street, High Barnes

| Builder | Architect | No. of cottages | Date | TWAS Ref. |
|---|---|---|---|---|
| J. W. White | W. and T. R. Milburn | 6 | 20 Jan 1899 | 269/1842 |
| J. W. White | W. and T. R. Milburn | 14 | 24 Jan 1899 | 269/1843 |
| J. W. White | W. and T. R. Milburn | 20 | 24 Jan 1899 | 269/1844 |
| J. Burdes | W. and T. R. Milburn | 2 | 27 May 1904 | 269/1845 |
| J. W. White | W. and T. R. Milburn | 8 | 20 Aug 1904 | 269/1846 |
| R. W. Stutt | W. and T. R. Milburn | 2 | 30 Aug 1904 | 269/1847 |
| J. W. White | W. and T. R. Milburn | 3 | 21 Feb 1905 | 269/1848 |

## Edwin Street, Pallion

| Builder | Architect | No. of cottages | Date | TWAS Ref. |
|---|---|---|---|---|
| William Halcro | Middlemiss and Green | 4 | 9 Oct 1885 | 269/1890 |
| Thomas Spain | R. C. Green | 4 | 21 Jul 1892 | 269/1887 |
| Thomas Spain | Joseph Spain | 9 | 5 Aug 1892 | 269/1889 |
| H. Iliff | Joseph Spain | 3 | 30 Mar 1897 | 269/1888 |

## Eglington Street, Monkwearmouth

| Builder | Architect | No. of cottages | Date | TWAS Ref. |
|---|---|---|---|---|
| John Emmerson | Unknown | 2 | 26 May 1882 | 269/1897 |

### Elizabeth Street, Castletown

| Builder | Architect | No. of cottages | Date | TWAS Ref. |
| --- | --- | --- | --- | --- |
| John Elrick | T. R. Milburn | 2 | 5 Apr 1888 | 269/1910 |

### Empress Street, Southwick

| Builder | Architect | No. of cottages | Date | TWAS Ref. |
| --- | --- | --- | --- | --- |
| Monkwearmouth Coal Company | J. and T. Tillman | 15 | 18 Mar 1880 | 269/1917 |

### Exeter Street, Pallion

| Builder | Architect | No. of cottages | Date | TWAS Ref. |
| --- | --- | --- | --- | --- |
| M. McGlynn | William Dent | 1 | 11 Feb 1925 | 269/2021 |
| M. McGlynn | William Dent | 1 | 11 Feb 1925 | 269/2022 |
| M. McGlynn | William Dent | 1 | 11 Feb 1925 | 269/2023 |
| M. McGlynn | William Dent | 1 | 11 Feb 1925 | 269/2024 |

### Florence Crescent, Southwick

| Builder | Architect | No. of cottages | Date | TWAS Ref. |
| --- | --- | --- | --- | --- |
| William Dinning | H. T. D. Hedley | 5 | 20 Jun 1900 | 269/2131 |
| William Dinning | H. T. D. Hedley | 1 | 27 Jun 1900 | 269/2130 |

### Forfar Street, Fulwell

| Builder | Architect | No. of cottages | Date | TWAS Ref. |
| --- | --- | --- | --- | --- |
| J. R. Birney | Joseph Potts and Son | 12 | 19 Mar 1906 | 269/2175 |
| Hartness and Fisher | Joseph Potts and Son | 1 | 9 Sep 1925 | 269/2176 |
| C. B. Carr | Joseph Potts and Son | 2 | 11 Nov 1925 | 269/2177 |
| C. B. Carr | Joseph Potts and Son | 2 | 1 Mar 1926 | 269/2178 |
| C. R. Wills | Joseph Potts and Son | 2 | 14 Apr 1926 | 269/2179 |
| C. B. Carr | Joseph Potts and Son | 9 | 14 Apr 1926 | 269/2180 |
| C. R. Wills | Joseph Potts and Son | 7 | 13 Oct 1926 | 269/2182 |
| C. R. Wills | Joseph Potts and Son | 7 | 10 Nov 1926 | 269/2183 |
| C. R. Wills | Joseph Potts and Son | 2 | 9 Nov 1927 | 269/2184 |

### Forster Street, Fulwell

| Builder | Architect | No. of cottages | Date | TWAS Ref. |
| --- | --- | --- | --- | --- |
| George Swan | Unknown | 6 | 2 Oct 1890 | 269/2189 |
| Frank H. Storey | Unknown | 7 | 11 Dec 1890 | 269/2185 |
| Frank H. Storey | Unknown | 5 | 11 Jun 1891 | 269/2198 |
| Frank H. Storey | Unknown | 1 | 12 April 1892 | 269/2186 |
| George Swan | Unknown | 2 | 26 May 1892 | 269/2187 |
| George Swan | Unknown | 2 | 8 Dec 1892 | 269/2190 |
| George Swan | Unknown | 2 | 28 Mar 1893 | 269/2191 |
| George Swan | Unknown | 7 | 6 Jun 1895 | 269/2193 |
| Frank H. Storey | Unknown | 7 | 4 July 1895 | 269/2194 |

## Francis Street, Monkwearmouth

| Builder | Architect | No. of cottages | Date | TWAS Ref. |
| --- | --- | --- | --- | --- |
| James Palmer | Joseph Potts and Son | 6 | 27 Feb 1900 | 269/2226 |
| John Batty | Joseph Potts and Son | 2 | 21 Feb 1907 | 269/2227 |
| John Batty | Joseph Potts and Son | 2 | 25 Feb 1907 | 269/2228 |
| John Batty | Joseph Potts and Son | 2 | 21 Jun 1907 | 269/2229 |

## Fulwell Road, Monkwearmouth

| Builder | Architect | No. of cottages | Date | TWAS Ref. |
| --- | --- | --- | --- | --- |
| George Strong | W. and T. R. Milburn | 11 | 30 Aug 1898 | 269/2294 |
| Frank H. Storey | W. and T. R. Milburn | 17 | 27 Nov 1900 | 269/2296 |
| Frank H. Storey | W. and T. R. Milburn | 1 | 26 Jul 1906 | 269/2308 |

## Garfield Street, Pallion

| Builder | Architect | No. of cottages | Date | TWAS Ref. |
| --- | --- | --- | --- | --- |
| W. J. Brown | John Eltringham | 3 | 17 Jul 1885 | 269/2354 |
| J. G. Lister | John Eltringham | 4 | 29 Jul 1885 | 269/2355 |

## Garnet Street, Pallion

| Builder | Architect | No. of cottages | Date | TWAS Ref. |
| --- | --- | --- | --- | --- |
| J. W. Campbell | E. J. Wilson | 13 | 24 Dec 1898 | 269/2356 |
| J. W. Campbell | E. J. Wilson | 5 | 24 Jan 1899 | 269/2357 |
| W. G. Browell | E. J. Wilson | 13 | 28 Nov 1899 | 269/2358 |

## General Graham Street, Millfield

| Builder | Architect | No. of cottages | Date | TWAS Ref. |
| --- | --- | --- | --- | --- |
| Robert S. Allan | William Milburn | 4 | 12 May 1892 | 269/2389 |
| Unknown | William Milburn | 6 | 12 May 1892 | 269/2390 |
| John Emmerson and Son | William Milburn | 1 | 10 Nov 1892 | 269/2391 |
| Unknown | William Milburn | 6 | 16 Feb 1893 | 269/2392 |
| J. W. Leithes | William Milburn | 3 | 2 Mar 1893 | 269/2393 |
| William Leithes | William Milburn | 2 | 16 Mar 1893 | 269/2394 |
| Unknown | William Milburn | 2 | 13 Apr 1893 | 269/2395 |
| William Leithes | William Milburn | 3 | 25 May 1893 | 269/2398 |
| John Emmerson and Son | William Milburn | 3 | 22 Jun 1893 | 269/2399 |
| Woodhill and Kirtley | Thomas Ridley Milburn | 2 | 13 Sep 1894 | 269/2401 |
| H. Abram | William Milburn | 1 | 6 Dec 1894 | 269/2403 |
| William Leithes | William Milburn | 6 | 19 Dec 1894 | 269/2404 |
| William Atkinson | William Milburn | 6 | 29 Dec 1894 | 269/2405 |
| J. Davis | William Milburn | 3 | 23 Jun 1896 | 269/2409 |
| George Trotter | William Milburn | 4 | 27 Jul 1896 | 269/2410 |
| William Leithes | William Milburn | 3 | 27 Jul 1896 | 269/2411 |
| Willis and Monk | W. and T. R. Milburn | 2 | 27 Jul 1896 | 269/2412 |

| John Graham | W. and T. R. Milburn | 1 | 25 Apr 1900 | 269/2423 |
| John Graham | W. and T. R. Milburn | 1 | 1 Feb 1904 | 269/2429 |

## Grange Street, Grangetown

| Builder | Architect | No. of cottages | Date | TWAS Ref. |
| --- | --- | --- | --- | --- |
| John Allan | W. and T. R. Milburn | 2 | 16 Oct 1903 | 269/2612 |
| Whitfield Brothers | W. and T. R. Milburn | 6 | 11 Feb 1904 | 269/2613 |
| Hall and Wharton | W. and T. R. Milburn | 2 | 21 Sep 1905 | 269/2615 |
| A. Johnson | W. and T. R. Milburn | 2 | 27 Sep 1905 | 269/2614 |
| W. Knaggs | F. E. Coats | 12 | 10 Jul 1923 | 269/2616 |
| W. Knaggs | F. E. Coats | 2 | 10 Aug 1933 | 269/2617 |

## Grindon Terrace, High Barnes

| Builder | Architect | No. of cottages | Date | TWAS Ref. |
| --- | --- | --- | --- | --- |
| J. W. Greenwell | William Milburn | 4 | 22 Jun 1893 | 269/2724 |
| J. B. Shilling | William Milburn | 2 | 6 Jul 1893 | 269/2725 |
| John Emmerson | William Milburn | 4 | 28 Sep 1893 | 269/2726 |
| W. G. Browell | William Milburn | 6 | 28 Sep 1893 | 269/2727 |
| W. Scott | William Milburn | 2 | 12 Apr 1894 | 269/2728 |
| George Maxfield | William Milburn | 2 | 21 Jun 1894 | 269/2729 |
| John Atkinson | William Milburn | 3 | 5 Jul 1894 | 269/2730 |
| John Emmerson and Son | William Milburn | 2 | 19 Jul 1894 | 269/2731 |
| J. Clark | William Milburn | 2 | 1 Aug 1894 | 269/2732 |

## Grosvenor Street, Southwick

| Builder | Architect | No. of cottages | Date | TWAS Ref. |
| --- | --- | --- | --- | --- |
| Archibald S. Harper | Hugh Hedley | 3 | 25 Sep 1900 | 269/2746 |
| John G. Hedley | Hugh Hedley | 17 | 27 Oct 1900 | 269/2747 |
| W. Kirby | Hugh Hedley | 2 | 25 Apr 1901 | 269/2745 |
| R. Lazenby | Hugh Hedley | 2 | 27 Sep 1904 | 269/2740 |
| J. Long | Hedley and Clayton Greene | 8 | 7 Nov 1904 | 269/2743 |
| William Davison | Hedley and Clayton Greene | 3 | 23 Dec 1904 | 269/2736 |
| William Davison | Hedley and Clayton Greene | 2 | 23 Dec 1904 | 269/2739 |
| William Davison | Hedley and Clayton Greene | 11 | 23 Dec 1904 | 269/2744 |
| Unknown | Hedley and Clayton Greene | 2 | 30 Dec 1904 | 269/2742 |
| William Davison | Hedley and Clayton Greene | 2 | 20 Oct 1905 | 269/2735 |
| William Davison | Hedley and Clayton Greene | 2 | 20 Oct 1905 | 269/2741 |
| R. Lazenby | Hugh Hedley | 2 | 27 Sep 1909 | 269/2738 |
| S. Jacques | Hugh Hedley | 2 | 18 Apr 1934 | 269/2737 |

## Guisborough Street, High Barnes

| Builder | Architect | No. of cottages | Date | TWAS Ref. |
| --- | --- | --- | --- | --- |
| J. W. White | W. and T. R. Milburn | 18 | 24 Jan 1899 | 269/2756 |

| J. W. White | W. and T. R. Milburn | 18 | 28 Mar 1899 | 269/2757 |
| J. W. White | W. and T. R. Milburn | 8 | 26 Sep 1905 | 269/2758 |
| John Greenwell | W. and T. R. Milburn | 6 | 12 Jan 1906 | 269/2759 |
| J. Dodgson | W. and T. R. Milburn | 3 | 25 Jan 1906 | 269/2760 |
| J. W. White | W. and T. R. Milburn | 6 | 28 Feb 1906 | 269/2761 |
| J. W. White | W. and T. R. Milburn | 4 | 20 Jun 1906 | 269/2762 |
| John Greenwell | W. and T. R. Milburn | 6 | 3 Aug 1906 | 269/2763 |
| J. W. White | W. and T. R. Milburn | 6 | 3 Oct 1906 | 269/2764 |
| J. W. White | W. and T. R. Milburn | 6 | 14 Mar 1907 | 269/2765 |

## Hampden Road, Monkwearmouth

| Builder | Architect | No. of cottages | Date | TWAS Ref. |
| --- | --- | --- | --- | --- |
| Unknown | W. and T. R. Milburn | 15 | 21 Dec 1898 | 269/2777 |
| Unknown | W. and T. R. Milburn | 7 | 21 Dec 1898 | 269/2779 |
| A. M. Oliver | W. and T. R. Milburn | 2 | 26 Apr 1904 | 269/2780 |
| Frank H. Storey | W. and T. R. Milburn | 12 | 26 Apr 1904 | 269/2781 |
| Unknown | W. and T. R. Milburn | 2 | 25 Jul 1904 | 269/2782 |
| Unknown | W. and T. R. Milburn | 5 | 27 Sep 1904 | 269/2783 |
| Frank H. Storey | W. and T. R. Milburn | 2 | 25 Oct 1904 | 269/2784 |
| Unknown | W. and T. R. Milburn | 1 | 18 Jan 1905 | 269/2785 |
| Frank H. Storey | W. and T. R. Milburn | 8 | 16 Feb 1905 | 269/2786 |
| Unknown | W. and T. R. Milburn | 2 | 9 May 1905 | 269/2787 |
| North Eastern Banking Company | W. and T. R. Milburn | 1 | 26 Sep 1913 | 269/2778 |

## Hartington Street, Monkwearmouth

| Builder | Architect | No. of cottages | Date | TWAS Ref. |
| --- | --- | --- | --- | --- |
| George Dixon | Unknown | 2 | 22 Nov 1889 | 269/2839 |
| Thomas Stephenson | Unknown | 2 | 27 Apr 1893 | 269/2826 |
| Thomas Newby | Unknown | 2 | 25 Oct 1894 | 269/2827 |
| John Elrick | Unknown | 8 | 8 Nov 1894 | 269/2828 |
| Thomas Newby | Unknown | 5 | 30 Jan 1895 | 269/2829 |
| Thomas Newby | Joseph Potts and Son | 1 | 25 May 1897 | 269/2830 |
| T. Armstrong | Joseph Potts and Son | 1 | 1 Oct 1903 | 269/2833 |

## Hawarden Crescent, High Barnes

| Builder | Architect | No. of cottages | Date | TWAS Ref. |
| --- | --- | --- | --- | --- |
| Unknown | W. and T. R. Milburn | 17 | 22 Mar 1899 | 269/2885 |
| J. W. White | W. and T. R. Milburn | 21 | 30 May 1899 | 269/2886 |
| Unknown | W. and T. R. Milburn | 18 | 30 May 1899 | 269/2887 |
| William Leithes | W. and T. R. Milburn | 2 | 25 Sep 1900 | 269/2888 |
| William Leithes | W. and T. R. Milburn | 2 | 17 Dec 1900 | 269/2889 |
| J. W. Tiffin | W. and T. R. Milburn | 1 | 27 Mar 1901 | 269/2890 |

| | | | | |
|---|---|---|---|---|
| J. W. White | W. and T. R. Milburn | 20 | 25 Jun 1901 | 269/2892 |
| William Leithes | W. and T. R. Milburn | 1 | 25 Jun 1901 | 269/2893 |
| Oxley and Pitt | W. and T. R. Milburn | 1 | 25 Jul 1901 | 269/2894 |
| J. Leithes | W. and T. R. Milburn | 6 | 22 May 1903 | 269/2895 |
| Unknown | W. and T. R. Milburn | 16 | 22 May 1903 | 269/2896 |
| J. Hodgson | W. and T. R. Milburn | 3 | 2 Jun 1903 | 269/2897 |
| J. Stothard | W. and T. R. Milburn | 6 | 16 Jun 1903 | 269/2898 |
| J. Hodgson | W. and T. R. Milburn | 3 | 29 Sep 1903 | 269/2901 |
| R. W. Armstrong | W. and T. R. Milburn | 3 | 30 Sep 1903 | 269/2900 |
| R. W. Armstrong | W. and T. R. Milburn | 1 | 28 Nov 1903 | 269/2902 |
| R. W. Armstrong | W. and T. R. Milburn | 1 | 10 Dec 1903 | 269/2903 |
| Unknown | W. and T. R. Milburn | 21 | 26 Apr 1904 | 269/2904 |
| R. W. Armstrong | W. and T. R. Milburn | 3 | 22 Jul 1904 | 269/2905 |
| J. W. Greenwell | W. and T. R. Milburn | 6 | 25 Jul 1904 | 269/2906 |
| H. S. Pitt | W. and T. R. Milburn | 6 | 31 Oct 1904 | 269/2907 |
| J. Stothard | W. and T. R. Milburn | 2 | 31 Oct 1904 | 269/2908 |
| J. and W. Hodgson | W. and T. R. Milburn | 6 | 22 Nov 1904 | 269/2909 |
| J. W. Tiffin | W. and T. R. Milburn | 2 | 29 Nov 1904 | 269/2910 |
| J. and W. Hodgson | W. and T. R. Milburn | 1 | 30 Jun 1905 | 269/2913 |
| J. and W. Hodgson | W. and T. R. Milburn | 1 | 10 Nov 1905 | 269/2914 |

## Hazeldene Terrace, Pallion

| Builder | Architect | No. of cottages | Date | TWAS Ref. |
|---|---|---|---|---|
| Sunderland Equitable Industrial Society | W. and T. R. Milburn | 12 | 31 May 1899 | 269/2930 |
| Sunderland Equitable Industrial Society | W. and T. R. Milburn | 12 | 31 May 1899 | 269/2931 |
| Sunderland Equitable Industrial Society | W. and T. R. Milburn | 13 | 22 Apr 1901 | 269/2932 |

## Hendon Burn Avenue, Hendon

| Builder | Architect | No. of cottages | Date | TWAS Ref. |
|---|---|---|---|---|
| G. and J. M. Gibbons | Unknown | 2 | 14 May 1880 | 269/2949 |
| J. Hirst and Son | Unknown | 4 | 14 May 1880 | 269/2952 |
| G. and J. M. Gibbons | Unknown | 4 | 28 May 1880 | 269/2941 |
| G. and J. M. Gibbons | Unknown | 6 | 3 Jan 1885 | 269/2948 |
| T. and J. Marshall | Unknown | 6 | 30 Jan 1885 | 269/2945 |
| G. and J. M. Gibbons | Unknown | 5 | 9 Oct 1885 | 269/2940 |
| G. and J. M. Gibbons | Unknown | 4 | 3 Dec 1885 | 269/2942 |

## Hendon Valley Road, Hendon

| Builder | Architect | No. of cottages | Date | TWAS Ref. |
|---|---|---|---|---|
| John Hutchinson | Unknown | 4 | 17 Jan 1887 | 269/3005 |

## Houghton Street, Pallion

| Builder | Architect | No. of cottages | Date | TWAS Ref. |
|---|---|---|---|---|
| Thomas P. Lewis | Unknown | 2 | 27 Jul 1878 | 269/3399 |
| William Anderson | Unknown | 2 | 4 Oct 1878 | 269/3410 |
| John William Barss | George Hildrey Jr. | 2 | 13 Dec 1878 | 269/3401 |
| William Adamson | George Hildrey Jr. | 9 | 27 Dec 1878 | 269/3402 |
| Matthew Reed | George Hildrey Jr. | 2 | 4 Apr 1879 | 269/3403 |
| Joseph L. Dumble | George Hildrey Jr. | 1 | 20 Aug 1880 | 269/3404 |
| James Frattles | George Hildrey Jr. | 2 | 22 Jul 1881 | 269/3405 |
| H. A. Butt | Unknown | 1 | 14 Sep 1883 | 269/3406 |

## Hylton Street, Millfield

| Builder | Architect | No. of cottages | Date | TWAS Ref. |
|---|---|---|---|---|
| Thomas W. Davison | Unknown | 6 | 14 Dec 1877 | 269/3559 |
| Jonathan Priestley | George Hildrey | 9 | 5 Mar 1880 | 269/3557 |
| Thomas W. Davison | Unknown | 6 | 21 May 1880 | 269/3556 |
| Richard and Thomas Sumby | Unknown | 5 | 6 Sep 1898 | 269/3558 |

## Inverness Street, Fulwell

| Builder | Architect | No. of cottages | Date | TWAS Ref. |
|---|---|---|---|---|
| John Elrick | Joseph Potts and Son | 27 | 24 Jan 1899 | 269/3574 |
| Frank H. Storey | Joseph Potts and Son | 28 | 28 Mar 1899 | 269/3575 |
| Frank H. Storey | Joseph Potts and Son | 10 | 28 Mar 1899 | 269/3576 |
| John Elrick | Joseph Potts and Son | 10 | 28 Mar 1899 | 269/3577 |
| G. E. Simpson | Joseph Potts and Son | 12 | 30 Jan 1906 | 269/3578 |
| G. H. Prior | Joseph Potts and Son | 10 | 14 Feb 1906 | 269/3579 |
| William Watson and Company | Joseph Potts and Son | 12 | 27 Mar 1906 | 269/3580 |
| J. P. Tindle | Joseph Potts and Son | 2 | 27 Mar 1906 | 269/3581 |
| R. W. Armstrong | Joseph Potts and Son | 2 | 26 Jan 1907 | 269/3582 |
| William Watson and Company | Joseph Potts and Son | 4 | 26 Feb 1908 | 269/3583 |
| Andrew Ridley | Joseph Potts and Son | 2 | 24 Jul 1908 | 269/3584 |
| William Watson and Company | Joseph Potts and Son | 1 | 22 May 1909 | 269/3585 |
| W. Rackstraw and F. Thompson | Joseph Potts and Son | 7 | 10 Oct 1923 | 269/3587 |
| T. Scrafton | Joseph Potts and Son | 2 | 13 Feb 1924 | 269/3588 |
| R. W. Scott and Company | Joseph Potts and Son | 6 | 13 Feb 1924 | 269/3589 |
| R. W. Scott and Company | Joseph Potts and Son | 2 | 10 Sep 1924 | 269/3590 |
| R. W. Scott and Company | Joseph Potts and Son | 6 | 12 Nov 1924 | 269/3591 |
| R. W. Scott and Company | Joseph Potts and Son | 7 | 13 May 1925 | 269/3592 |
| H. I. Green | Joseph Potts and Son | 3 | 9 Sep 1925 | 269/3594 |
| R. W. Scott and Company | Joseph Potts and Son | 4 | 14 Apr 1926 | 269/3595 |
| T. Scrafton | Joseph Potts and Son | 2 | 14 Apr 1926 | 269/3596 |
| T. Scrafton | Joseph Potts and Son | 2 | 10 Nov 1926 | 269/3597 |
| C. B. Carr | Joseph Potts and Son | 6 | 10 Nov 1926 | 269/3598 |

## James Street, Southwick

| Builder | Architect | No. of cottages | Date | TWAS Ref. |
| --- | --- | --- | --- | --- |
| W. Thompson | Hedley and Clayton-Greene | 5 | 16 Dec 1902 | 269/3623 |

## John Candlish Road, Millfield

| Builder | Architect | No. of cottages | Date | TWAS Ref. |
| --- | --- | --- | --- | --- |
| P. Kelly and P. Calsert | Unknown | 2 | 20 Jun 1884 | 269/3731 |
| Oswald Dent | Middlemiss, Green and Hedley | 2 | 30 Jul 1895 | 269/3738 |

## King's Place, Millfield

| Builder | Architect | No. of cottages | Date | TWAS Ref. |
| --- | --- | --- | --- | --- |
| Donald James Paxton | G. A. Middlemiss | 2 | 19 Jan 1883 | 269/3813 |
| Donald James Paxton | Unknown | 6 | 10 Oct 1884 | 269/3815 |

## King's Road, Southwick

| Builder | Architect | No. of cottages | Date | TWAS Ref. |
| --- | --- | --- | --- | --- |
| J. W. Hastie | Unknown | 9 | 13 Mar 1874 | 269/3824 |
| George Strong | Unknown | 2 | 23 Apr 1875 | 269/3822 |
| Oswald Dent | Middlemiss, Green and Hedley | 2 | 15 Aug 1895 | 269/3827 |

## King's Terrace, Pallion

| Builder | Architect | No. of cottages | Date | TWAS Ref. |
| --- | --- | --- | --- | --- |
| T. J. Nesbit | E. Sidney Wilson | 17 | 25 Jan 1898 | 269/3842 |
| T. J. Nesbit | E. Sidney Wilson | 23 | 22 Feb 1898 | 269/3843 |
| T. H. Dunwoodie | G. T. Brown | 6 | 29 Oct 1901 | 269/3844 |
| T. H. Dunwoodie | G. T. Brown | 8 | 26 Nov 1901 | 269/3845 |
| T. H. Dunwoodie | G. T. Brown | 7 | 24 Dec 1901 | 269/3846 |

## Kingston Terrace, Monkwearmouth

| Builder | Architect | No. of cottages | Date | TWAS Ref. |
| --- | --- | --- | --- | --- |
| Unknown | W. and T. R. Milburn | 16 | 9 Oct 1901 | 269/3852 |
| J. M. Wright | W. and T. R. Milburn | 2 | 28 Feb 1902 | 269/3853 |
| M. Oliver | W. and T. R. Milburn | 2 | 27 May 1902 | 269/3854 |
| Frank H. Storey | W. and T. R. Milburn | 2 | 29 Sep 1903 | 269/3855 |

## Kitchener Street, High Barnes

| Builder | Architect | No. of cottages | Date | TWAS Ref. |
| --- | --- | --- | --- | --- |
| J. W. White | W. and T. R. Milburn | 25 | 24 Nov 1898 | 269/3856 |
| J. W. White | W. and T. R. Milburn | 25 | 25 Nov 1898 | 269/3857 |
| J. W. White | W. and T. R. Milburn | 20 | 22 Dec 1898 | 269/3858 |

| | | | | |
|---|---|---|---|---|
| J. Pearson | W. and T. R. Milburn | 2 | 25 May 1901 | 269/3859 |
| John Graham | W. and T. R. Milburn | 1 | 23 Aug 1904 | 269/3860 |
| John Graham | W. and T. R. Milburn | 2 | 14 Apr 1905 | 269/3861 |
| H. Potter | W. and T. R. Milburn | 6 | 14 Nov 1923 | 269/3862 |

## Laws Street, Fulwell

| Builder | Architect | No. of cottages | Date | TWAS Ref. |
|---|---|---|---|---|
| J. Lees | A. E. King | 1 | 31 May 1907 | 269/3909 |

## Leechmere Road, Grangetown

| Builder | Architect | No. of cottages | Date | TWAS Ref. |
|---|---|---|---|---|
| W. Stainsby | Joseph Spain | 2 | 8 Oct 1908 | 269/3925 |
| W. Stainsby | Joseph Spain | 5 | 9 Mar 1909 | 269/3927 |
| W. Stainsby | George T. Brown | 3 | 30 Sep 1910 | 269/3928 |

## Lily Street, Millfield

| Builder | Architect | No. of cottages | Date | TWAS Ref. |
|---|---|---|---|---|
| James Hartley and Co. | James Henderson | 20 | 26 Jul 1897 | 269/3934 |
| James Hartley and Co. | James Henderson | 15 | 25 Aug 1897 | 269/3935 |
| David Spark | Henderson and Hall | 1 | 30 Mar 1899 | 269/3937 |

## Lime Street, Millfield

| Builder | Architect | No. of cottages | Date | TWAS Ref. |
|---|---|---|---|---|
| J. Rice | W. and T. R. Milburn | 1 | 26 Jun 1900 | 269/3939 |

## Mafeking Street, Pallion

| Builder | Architect | No. of cottages | Date | TWAS Ref. |
|---|---|---|---|---|
| William Sanderson | W. and T. R. Milburn | 15 | 30 Oct 1900 | 269/4086 |
| J. W. White | D. White | 21 | 18 Jul 1924 | 269/4087 |

## May Street, Pallion

| Builder | Architect | No. of cottages | Date | TWAS Ref. |
|---|---|---|---|---|
| James Hartley and Co. | James Henderson | 20 | 27 Apr 1897 | 269/4143 |
| James Hartley and Co. | James Henderson | 20 | 27 Apr 1897 | 269/4144 |

## Moray Street, Fulwell

| Builder | Architect | No. of cottages | Date | TWAS Ref. |
|---|---|---|---|---|
| Seadon Brothers | Joseph Potts and Son | 2 | 13 May 1925 | 269/4244 |
| C. B. Carr | Joseph Potts and Son | 1 | 1 Mar 1926 | 269/4246 |
| C. B. Carr | Joseph Potts and Son | 2 | 24 Mar 1926 | 269/4254 |
| C. B. Carr | Joseph Potts and Son | 3 | 12 Oct 1927 | 269/4248 |
| C. B. Carr | Joseph Potts and Son | 1 | 11 Apr 1928 | 269/4249 |

| | | | | |
|---|---|---|---|---|
| Seadon Brothers | Joseph Potts and Son | 2 | 9 Sep 1928 | 269/4250 |
| Unknown | Joseph Potts and Son | 1 | Mar 1933 | 269/4252 |
| C. B. Carr | Joseph Potts and Son | 2 | Unknown | 269/4247 |

## Mortimer Street, Pallion

| Builder | Architect | No. of cottages | Date | TWAS Ref. |
|---|---|---|---|---|
| Burn and Shakespeare | Joseph Spain | 4 | 26 Oct 1899 | 269/4273 |
| Burn and Shakespeare | Joseph Spain | 1 | 20 Dec 1899 | 269/4274 |
| J. M. McGlynn | William Dent | 1 | Jan 1925 | 269/4275 |
| J. M. McGlynn | Unknown | 1 | 9 Dec 1932 | 269/4276 |

## Nora Street, High Barnes

| Builder | Architect | No. of cottages | Date | TWAS Ref. |
|---|---|---|---|---|
| J. W. White | W. and T. R. Milburn | 25 | 18 Nov 1898 | 269/4504 |
| J. W. White | W. and T. R. Milburn | 19 | 23 Dec 1898 | 269/4507 |
| J. W. White | W. and T. R. Milburn | 25 | Unknown | 269/4506 |

## Ocean Road, Grangetown

| Builder | Architect | No. of cottages | Date | TWAS Ref. |
|---|---|---|---|---|
| Jonathan Priestley | William Milburn | 2 | 10 Oct 1884 | 269/4683 |
| Robinson and Brunsmitt | William Milburn | 2 | 24 Oct 1884 | 269/4684 |
| Joseph Tyers | William Milburn | 2 | 5 Dec 1884 | 269/4685 |
| M. Davis | Unknown | 2 | 27 Mar 1885 | 269/4686 |
| Thomas Miller | W. and T. R. Milburn | 2 | 3 Mar 1892 | 269/4687 |
| William Miller | William Milburn | 2 | 12 May 1892 | 269/4688 |

## Onslow Street

| Builder | Architect | No. of cottages | Date | TWAS Ref. |
|---|---|---|---|---|
| Unknown | J. Cecil Clavering | 7 | 22 Jun 1933 | 269/4711 |
| M. Behrman | J. Cecil Clavering | 3 | 22 Jun 1933 | 269/4712 |

## Osborne Street, Pallion

| Builder | Architect | No. of cottages | Date | TWAS Ref. |
|---|---|---|---|---|
| George Swan | Joseph Potts and Son | 1 | 25 Sep 1899 | 269/4756 |

## Pickard Street, Pallion

| Builder | Architect | No. of cottages | Date | TWAS Ref. |
|---|---|---|---|---|
| Joseph Hurst | A. Wardropper | 2 | 22 Nov 1884 | 269/5131 |
| Charles Bell | John Eltringham | 1 | 3 Mar 1892 | 269/5133 |

## Queen's Crescent, High Barnes

| Builder | Architect | No. of cottages | Date | TWAS Ref. |
|---|---|---|---|---|
| John Parker | W. and T. R. Milburn | 2 | 27 Mar 1897 | 269/5242 |

| J. Emmerson | W. and T. R. Milburn | 4 | 27 Mar 1897 | 269/5243 |
|---|---|---|---|---|
| William Leithes | W. and T. R. Milburn | 6 | 29 Mar 1897 | 269/5244 |
| John Greenwell | W. and T. R. Milburn | 2 | 30 Mar 1897 | 269/5245 |
| George Jopling | W. and T. R. Milburn | 4 | 30 Mar 1897 | 269/5246 |
| Mr. Raine | W. and T. R. Milburn | 2 | 24 May 1897 | 269/5247 |
| John Graham | W. and T. R. Milburn | 2 | 24 May 1897 | 269/5148 |
| A. Howarth | W. and T. R. Milburn | 4 | 29 Jun 1897 | 269/5149 |
| C. Wilkinson | W. and T. R. Milburn | 6 | 27 Jul 1897 | 269/5150 |
| J. W. White | W. and T. R. Milburn | 2 | 24 Aug 1897 | 269/5151 |
| William Leithes | W. and T. R. Milburn | 2 | 24 Aug 1897 | 269/5152 |
| J. W. White | W. and T. R. Milburn | 2 | 29 Sep 1897 | 269/5153 |
| J. W. White | W. and T. R. Milburn | 2 | 29 Sep 1897 | 269/5154 |
| William Leithes | W. and T. R. Milburn | 1 | 27 Oct 1897 | 269/5155 |
| J. Emmerson | W. and T. R. Milburn | 4 | 23 Nov 1897 | 269/5156 |
| George Trotter | W. and T. R. Milburn | 4 | 23 Nov 1897 | 269/5157 |
| William Leithes | W. and T. R. Milburn | 6 | 23 Nov 1897 | 269/5158 |
| John Parker | W. and T. R. Milburn | 4 | 24 Nov 1897 | 269/5159 |
| Unknown | W. and T. R. Milburn | 19 | 29 Nov 1898 | 269/5160 |
| Unknown | W. and T. R. Milburn | 18 | 29 Nov 1898 | 269/5161 |
| Unknown | W. and T. R. Milburn | 11 | 30 May 1899 | 269/5162 |
| Unknown | W. and T. R. Milburn | 1 | 26 Feb 1900 | 269/5164 |
| J. W. Tiffin | W. and T. R. Milburn | 1 | 27 Mar 1901 | 269/5165 |
| William Leithes | W. and T. R. Milburn | 1 | 28 Mar 1901 | 269/5166 |
| William Leithes | W. and T. R. Milburn | 1 | 25 May 1901 | 269/5167 |
| William Leithes | W. and T. R. Milburn | 1 | Unknown | 269/5168 |
| J. Berriman | W. and T. R. Milburn | 2 | Unknown | 269/5169 |

## Rainton Street, Millfield

| Builder | Architect | No. of cottages | Date | TWAS Ref. |
|---|---|---|---|---|
| Matthew J. Davis | Unknown | 2 | 16 Feb 1883 | 269/5334 |
| Wilkin and Martin | Unknown | 2 | 27 Apr 1883 | 269/5335 |
| John William Barss | Unknown | 3 | 25 May 1883 | 269/5336 |
| John Sutton | Unknown | 3 | 25 May 1883 | 269/5337 |

## Ravensworth Street, Millfield

| Builder | Architect | No. of cottages | Date | TWAS Ref. |
|---|---|---|---|---|
| North Eastern Breweries | R. Earnshaw | 2 | 1 Sep 1913 | 269/5350 |

## Regent Terrace, Grangetown

| Builder | Architect | No. of cottages | Date | TWAS Ref. |
|---|---|---|---|---|
| James Laws | Middlemiss, Green and Hedley | 18 | 30 Mar 1897 | 269/5369 |
| E. Marshall | G. G. Donkin | 11 | 29 May 1900 | 269/5370 |

## Reginald Street, Pallion

| Builder | Architect | No. of cottages | Date | TWAS Ref. |
|---|---|---|---|---|
| J. L. Howarth | W. and T. R. Milburn | 10 | 14 Aug 1899 | 269/5371 |
| M. McGlynn | W. and T. R. Milburn | 10 | 13 Jun 1923 | 269/641 |
| M. McGlynn | W. and T. R. Milburn | 10 | 13 Jun 1923 | 269/642 |

## Rose, Violet and Trimdon Streets, Millfield

| Builder | Architect | No. of cottages | Date | TWAS Ref. |
|---|---|---|---|---|
| James Hartley and Co. | James Henderson | 80 | Unknown | 269/5693 |

## Rosedale Street, Millfield

| Builder | Architect | No. of cottages | Date | TWAS Ref. |
|---|---|---|---|---|
| Edward Gregson | Unknown | 2 | 13 Jun 1877 | 269/5695 |
| W. J. Porter | Unknown | 2 | 6 Jun 1884 | 269/5696 |
| T. Crozier | William Crozier | 1 | 22 Jul 1903 | 269/5701 |

## Roxburgh Street, Fulwell

| Builder | Architect | No. of cottages | Date | TWAS Ref. |
|---|---|---|---|---|
| George Swan | Joseph Potts and Son | 25 | 24 Jan 1899 | 269/5732 |
| Frank H. Storey | Joseph Potts and Son | 26 | 24 Jan 1899 | 269/5733 |
| H. Potter | Henderson and Hall | 1 | 27 May 1899 | 269/7210 |
| James Palmer | Joseph Potts and Son | 4 | 29 Jun 1900 | 269/5734 |
| Frank H. Storey | Joseph Potts and Son | 1 | 27 Jan 1903 | 269/5735 |
| James Palmer | Joseph Potts and Son | 6 | 24 Mar 1904 | 269/5737 |
| A. Young | Joseph Potts and Son | 1 | 26 Oct 1904 | 269/5738 |
| John Batty | Joseph Potts and Son | 4 | 16 Feb 1905 | 269/5739 |
| Mr. Palmer | Joseph Potts and Son | 1 | 22 Feb 1905 | 269/5740 |
| John Stephenson | Joseph Potts and Son | 2 | 22 Mar 1905 | 269/5741 |
| S. Lister | Joseph Potts and Son | 5 | 22 Sep 1905 | 269/5742 |
| John Stephenson | Joseph Potts and Son | 2 | 23 Sep 1905 | 269/5743 |
| Robert Muirhead | Joseph Potts and Son | 1 | 8 Sep 1906 | 269/5731 |
| John Batty | Joseph Potts and Son | 3 | 30 Oct 1906 | 269/5744 |
| Robert Muirhead | Joseph Potts and Son | 1 | 22 Sep 1908 | 269/5745 |

## Rutland Street, Pallion

| Builder | Architect | No. of cottages | Date | TWAS Ref. |
|---|---|---|---|---|
| Oswald Dent | E. Sidney Wilson | 10 | 26 Jul 1898 | 269/5762 |

## Sandringham Road, Monkwearmouth

| Builder | Architect | No. of cottages | Date | TWAS Ref. |
|---|---|---|---|---|
| J. Henderson and Son | W. and T. R. Milburn | 17 | 28 Mar 1901 | 269/6046 |
| G. H. Prior | W. and T. R. Milburn | 1 | 12 Jan 1905 | 269/6052 |
| J. Hodgson | W. and T. R. Milburn | 8 | 8 Apr 1905 | 269/6048 |

## Shepherd Street, Millfield

| Builder | Architect | No. of cottages | Date | TWAS Ref. |
| --- | --- | --- | --- | --- |
| Robert Davis | John Eltringham | 8 | 30 Mar 1897 | 269/6181 |
| Robert Thompson | Unknown | 2 | 28 Jun 1898 | 269/6182 |
| William Renny | John Eltringham | 4 | 26 Jun 1900 | 269/6183 |
| John Parker | John Eltringham | 4 | 24 Jul 1900 | 269/6184 |
| J. F. Wilson | John Eltringham | 4 | 20 Mar 1902 | 269/6185 |
| J. Pearson | John Eltringham | 5 | 24 Jul 1906 | 269/6186 |
| J. Pearson | John Eltringham | 1 | 4 Feb 1907 | 269/6187 |

## Sorley Street, Millfield

| Builder | Architect | No. of cottages | Date | TWAS Ref. |
| --- | --- | --- | --- | --- |
| John Young | John Eltringham | 4 | 11 Sep 1885 | 269/6259 |
| William M. Skinner | John Eltringham | 3 | 14 Sep 1893 | 269/6266 |
| William M. Skinner | John Eltringham | 3 | 28 Sep 1893 | 269/6267 |
| William M. Skinner | John Eltringham | 3 | 9 Nov 1893 | 269/6268 |
| J. M. H. Vasey | John Eltringham | 1 | 1 Aug 1894 | 269/6270 |
| H. A. Butt | John Eltringham | 1 | Unknown | 269/6260 |

## St Leonard's Street, Hendon

| Builder | Architect | No. of cottages | Date | TWAS Ref. |
| --- | --- | --- | --- | --- |
| R. S. Smith | H. E. Robinson | 6 | 21 Aug 1900 | 269/5919 |
| T. T. Martin | H. E. Robinson | 6 | 29 Aug 1900 | 269/5889 |
| Barron and Frazer | H. E. Robinson | 2 | 14 May 1901 | 269/5890 |
| T. H. Dunwoodie | H. E. Robinson | 2 | 29 May 1901 | 269/5891 |
| Barron and Frazer | H. E. Robinson | 2 | 25 Jul 1901 | 269/5892 |
| Henry Bell | H. E. Robinson | 4 | 25 Jul 1901 | 269/5893 |
| T. H. Dunwoodie | H. E. Robinson | 2 | 27 Aug 1901 | 269/5894 |
| J. E. Graham | H. E. Robinson | 4 | 6 Nov 1901 | 269/5895 |
| Wearmouth Coal Company | H. E. Robinson | 19 | 18 Dec 1901 | 269/5896 |
| Wearmouth Coal Company | H. E. Robinson | 6 | 18 Dec 1901 | 269/5897 |
| James Briggs | H. E. Robinson | 5 | 25 Jul 1905 | 269/5898 |
| Mark Howarth | H. E. Robinson | 6 | 5 Oct 1905 | 269/5899 |
| Mark Howarth | H. E. Robinson | 6 | 30 Jan 1906 | 269/5901 |
| James Briggs | H. E. Robinson | 8 | 27 Mar 1906 | 269/5888 |
| W. A. Thompson | H. E. Robinson | 2 | 23 Jun 1906 | 269/5900 |
| R. Foreman | H. E. Robinson | 1 | 11 Jul 1906 | 269/5902 |
| A. R. Snowdon | H. E. Robinson | 4 | 19 Jul 1906 | 269/5903 |
| Mark Howarth | H. E. Robinson | 2 | 14 Mar 1907 | 269/5904 |
| R. Oliver | H. E. Robinson | 2 | 20 Apr 1907 | 269/5905 |
| R. Oliver | H. E. Robinson | 2 | 13 Aug 1907 | 269/5906 |
| Mark Howarth | H. E. Robinson | 2 | 27 Aug 1907 | 269/5907 |

| R. Oliver | H. E. Robinson | 2 | 22 Oct 1907 | 269/5908 |
| J. Garrow | H. E. Robinson | 2 | 25 Feb 1908 | 269/5910 |
| R. Oliver | H. E. Robinson | 2 | 25 Mar 1908 | 269/5911 |
| R. Oliver | H. E. Robinson | 2 | 26 May 1908 | 269/5912 |
| Mark Howarth | H. E. Robinson | 4 | 29 Sep 1908 | 269/5913 |
| J. Golding | H. E. Robinson | 1 | 20 Oct 1908 | 269/5914 |
| R. Oliver | H. E. Robinson | 2 | 28 Oct 1908 | 269/5915 |
| J. Golding | H. E. Robinson | 2 | 30 Dec 1908 | 269/5916 |
| R. Oliver | H. E. Robinson | 1 | 20 Oct 1909 | 269/5917 |
| C. T. Elliot | William Dent | 6 | 13 Feb 1924 | 269/5918 |
| H. Potter | Unknown | 6 | 16 Mar 1925 | 269/5922 |
| G. A. Brown | H. E. Robinson | 2 | 1 Mar 1926 | 269/5921 |
| H. Potter | Unknown | 6 | 9 Sep 1928 | 269/5920 |

## St Luke's Road, Millfield

| Builder | Architect | No. of cottages | Date | TWAS Ref. |
|---|---|---|---|---|
| W. G. Browell | E. Sidney Wilson | 29 | 20 Dec 1898 | 269/5925 |

## St Mark's Road, Pallion

| Builder | Architect | No. of cottages | Date | TWAS Ref. |
|---|---|---|---|---|
| J. H. Chrishop | William Milburn | 6 | 31 Aug 1883 | 269/5981 |
| J. H. Chrishop | William Milburn | 1 | 18 Jul 1884 | 269/5994 |

## St Mark's Terrace, Millfield

| Builder | Architect | No. of cottages | Date | TWAS Ref. |
|---|---|---|---|---|
| George and Robert Place | Unknown | 5 | 5 Apr 1878 | 269/6001 |
| Thomas Brown | Unknown | 4 | 16 May 1879 | 269/6002 |

## Stewart Street, Millfield

| Builder | Architect | No. of cottages | Date | TWAS Ref. |
|---|---|---|---|---|
| Christopher Jacques | William Milburn | 15 | 17 Jul 1885 | 269/6367 |
| W. G. Browell | William Milburn | 4 | 5 Jul 1891 | 269/6368 |

## Stratfield Street, Pallion

| Builder | Architect | No. of cottages | Date | TWAS Ref. |
|---|---|---|---|---|
| Kirtley and Nelson | W. and T. R. Milburn and R. C. Green | 14 | 24 Jan 1899 | 269/6416 |

## Tanfield Street, Pallion

| Builder | Architect | No. of cottages | Date | TWAS Ref. |
|---|---|---|---|---|
| Kirtley and Nelson | W. and T. R. Milburn | 14 | 20 Jan 1899 | 269/6505 |
| R. C. Green | W. and T. R. Milburn | 14 | 24 Jan 1899 | 269/6506 |
| W. Thornton | W. and T. R. Milburn | 16 | 26 Sep 1899 | 269/6507 |

| | | | | |
|---|---|---|---|---|
| Kirtley and Nelson | W. and T. R. Milburn | 2 | 30 Oct 1902 | 269/6508 |
| J. Stonehouse | W. and T. R. Milburn | 2 | 23 Feb 1904 | 269/6509 |
| Owners of the West Moore estate | A. B. Tiffin | 7 | 29 Mar 1904 | 269/6510 |
| Owners of the West Moore estate | A. B. Tiffin | 6 | 29 Mar 1904 | 269/6511 |

## Thelma Street, Millfield

| Builder | Architect | No. of cottages | Date | TWAS Ref. |
|---|---|---|---|---|
| Joseph Dixon | John Eltringham | 4 | 31 Mar 1897 | 269/6581 |
| J. M. H. Vasey | John Eltringham | 2 | 26 Aug 1897 | 269/6583 |
| Joseph Dixon | John Eltringham | 1 | 26 Oct 1897 | 269/6585 |
| Joseph Dixon | John Eltringham | 4 | 23 Nov 1897 | 269/6587 |
| Joseph Dixon | John Eltringham | 3 | 25 Jan 1898 | 269/6588 |
| Joseph Dixon | John Eltringham | 4 | 26 Apr 1898 | 269/6590 |
| David Spark | John Eltringham | 4 | 24 Oct 1899 | 269/6591 |
| James Leithes | John Eltringham | 5 | 27 Dec 1899 | 269/6592 |
| James Leithes | John Eltringham | 3 | 27 Dec 1899 | 269/6593 |
| W. H. Gradon | John Eltringham | 2 | 30 Jan 1900 | 269/6594 |
| David Spark | John Eltringham | 2 | 30 Jan 1900 | 269/6595 |
| W. H. Gradon | John Eltringham | 2 | 30 Jan 1900 | 269/6596 |
| M. Howarth | John Eltringham | 2 | 30 Jan 1900 | 269/6597 |
| James Leithes | John Eltringham | 1 | 30 Jan 1900 | 269/6598 |

## Thornbury Street, Millfield

| Builder | Architect | No. of cottages | Date | TWAS Ref. |
|---|---|---|---|---|
| Hornsby and Burns | John Eltringham | 2 | 27 Aug 1901 | 269/6631 |
| J. G. Parker | John Eltringham | 4 | 29 Nov 1910 | 269/6632 |

## Tintern Street, Millfield

| Builder | Architect | No. of cottages | Date | TWAS Ref. |
|---|---|---|---|---|
| George Trotter | William Milburn | 6 | 7 Dec 1883 | 269/6850 |
| W. Davis | William Milburn | 1 | 21 Dec 1883 | 269/6851 |
| J. M. Sumby | William Milburn | 2 | 24 Oct 1884 | 269/6852 |
| Richard and Thomas Sumby | William Milburn | 2 | 25 Sep 1885 | 269/6853 |
| Richard and Thomas Sumby | William Milburn | 2 | 3 Dec 1885 | 269/6854 |

## Trinity Street, Southwick

| Builder | Architect | No. of cottages | Date | TWAS Ref. |
|---|---|---|---|---|
| W. Pattison | Hedley and Clayton Greene | 2 | 3 Nov 1903 | 269/6915 |
| T. S. Thompson | Hedley and Clayton Greene | 3 | 25 Jul 1904 | 269/6916 |
| J. Pattison | Hedley and Clayton Greene | 6 | 2 Aug 1904 | 269/6917 |
| William Davison | Hedley and Clayton Greene | 4 | 23 Dec 1904 | 269/6919 |

| G. E. Pattison | Hedley and Clayton Greene | 2 | 4 Apr 1905 | 269/6920 |
| G. E. Pattison | Hedley and Clayton Greene | 2 | 10 Apr 1905 | 269/6921 |
| G. E. Pattison | Hedley and Clayton Greene | 8 | 27 May 1905 | 269/6922 |
| G. E. Pattison | Hedley and Clayton Greene | 2 | 17 Oct 1906 | 269/6923 |
| G. E. Pattison | Hedley and Clayton Greene | 3 | 22 Feb 1907 | 269/6924 |
| T. Fraser | Hugh Hedley | 1 | 18 April 1934 | 269/6926 |
| Miss H. F. Fletcher | Hugh Hedley | 1 | 20 Jun 1934 | 269/6916 |

## Vedra Street, Southwick

| Builder | Architect | No. of cottages | Date | TWAS Ref. |
| --- | --- | --- | --- | --- |
| John G. Hedley | John Eltringham | 12 | 4 Oct 1898 | 269/7057 |
| H. Illingworth | John Eltringham | 28 | 25 Sep 1911 | 269/7058 |
| Robert Thompson and Son | John Eltringham | 23 | 22 Jan 1914 | 269/7060 |
| Robert Thompson and Son | John Eltringham | 23 | 22 Jan 1914 | 269/7061 |
| J. R. Thompson and Son | John Eltringham | 6 | 7 Jul 1914 | 269/7063 |
| Executors of Robert Thompson | John Eltringham | 6 | 30 Oct 1914 | 269/7064 |
| J. R. Thompson and Son | John Eltringham | 2 | 23 Jan 1915 | 269/7065 |
| Executors of Robert Thompson | John Eltringham | 4 | 23 Jan 1915 | 269/7066 |

## Villette Path, Hendon

| Builder | Architect | No. of cottages | Date | TWAS Ref. |
| --- | --- | --- | --- | --- |
| J. W. White | Unknown | 29 | 13 Feb 1924 | 269/7087 |

## Wilson Street, Pallion

| Builder | Architect | No. of cottages | Date | TWAS Ref. |
| --- | --- | --- | --- | --- |
| John Parker | Unknown | 2 | 19 Sep 1878 | 269/7583 |
| Donald J. Paxton | Unknown | 2 | 15 Oct 1880 | 269/7584 |
| Thomas Welch | Joseph Spain | 1 | 30 Dec 1902 | 269/7585 |

# Notes

Chapter 1

1. Cookson, G. (2010) *Sunderland: Building a City*. Chichester: Phillimore, p.108.

2. Smith, J. W. and Holden, T. S. (1946) *Where Ships are Born: Sunderland, 1346–1946*. Sunderland: Thomas Reed, p. 1.

3. This reputation persisted into the 1960s, when 30,000 shipbuilding workers were employed in the town.

4. Dennis, N., (1970) People and Planning: *The sociology of housing in Sunderland*, Faber and Faber, p 136.

5. Milburn, G. E. and Miller, S. T. (ed.) (1988) *Sunderland: River, Town and People: a history from the 1780s*. Sunderland: Sunderland Borough Council, p. 222 gives fuller figures.

6. *Pigot's Directory*, 1822; *Ward's Directory*, 1900.

7. *Pigot's Directory*, 1822; *Kelly's Directory*, 1902.

8. *Building News*, 88, 7 April 1905, p. 516; 19 May 1905, p. 735.

9. Estate plan in Sunderland Museum.

10. Information from John Tumman.

11. Oliver and Tillman's designs were used further down High Street, but not, apparently, in James Williams Street. The housing on James Williams Street was occupied by river pilots based at Boddlewell Steps nearby.

12. Information from John Tumman.

13. 'Cholera in Sunderland', http://www.parliament.uk/about/living-heritage/transformingsociety/towncountry/towns/tyne-and-wear-case-study/introduction/cholera-in-sunderland/

14. Graham Potts has examined builder-architects who gained their expertise from the building trade rather than from formal architectural training. This tradition dominated provincial building until architecture began to be consolidated as a profession in the nineteenth century. See Potts, G. 'Builders and Architects' in Milburn, G. E. and Miller, S. T., *op cit*.

15. TWAS 269/6266, a plan of three cottages and corner-shop in Sorley Street, drawn by John Eltringham for William M. Skinner and dated 14 September 1893. See also 269/6267 and 269/6268.

16. Sutcliffe, A. (1974) (ed.) *Multi-Storey Living: The British Working-Class Experience*. London: Croom Helm. See also Gauldie, E. (1974) *Cruel Habitations*. George Allen and Unwin.

17. Faulkner, T. E. and Greg, A., (2001) John Dobson, 1785–1865: Architect of the North East Newcastle: Newcastle Libraries.

18. Fordyce, W. (1857) *Durham II*, p. 480; T. E. Faulkner and A. Greg, op. cit., 2001, p. 111; Monkwearmouth Local History Group, *More Monkwearmouth Memories*, 1990, p. 27 for photo of Victor Street (formerly Ann Street). Quotation from Fordyce.

19. Muthesius, S. (1982) *The English Terraced House*. New Haven: Yale University Press, p. 140.

20. Longstaffe, E. A. (1982) *New Housing in Sunderland, c. 1860–1870*, unpublished BA Dissertation, Sunderland Polytechnic.

21. In some cases, the front door opens directly into the front room.

22. Grundy, J. (2003) *Northern Pride*. London: Granada, p. 197.

23. Long, p. 105.

24. See Dennis, N. (1970) *People and Planning: the sociology of housing in Sunderland*. London: Faber and Faber, p.117. See also Tarn, J. N. (1973) *Five Per Cent Philanthropy: an account of housing in urban areas between 1840 and 1914*. London: Cambridge University Press.

25. Bowley, A. L. and Wood, G. (1919) *The Division of the Product Industry*. Clarendon Press, p. 29.

26. Daunton, M. J. (1983) *House and Home in the Victorian City: working class housing: 1850–1914*. London: Edward Arnold, p. 81.

27. *Royal Commission for Inquiring in the State of Large Towns and Populous Districts*: (HMSO, Second Report, Appendix: 1845), p. 192.

28. It is important to note that the two-up-two-downs found in many northern towns served a similar role, while even Tyneside flats had their own front and rear doors, and in many cases their own yard.

Chapter 2

1. From *c.* 1875 most of these plans were retained by the Corporation and are now preserved in the Tyne and Wear Archives.

2. *Builder*, 19, 2 February 1861, p. 81; 20 April 1861, p. 274.

3. Daunton, p. 84.

4. Borough of Sunderland, *Endorsement on Building Plans*. These were sets of building regulations that builders or architects were required to sign and submit with any plans they deposited. See, for example, TWAS 269/1 – plan of six houses in Abingdon Street, submitted 25 January 1898.

5. Long, p. 109.

6. Plan dated 20 June 1898 (TWAS).

7. *The Builder*, 1871.

8. Sunderland Bye-laws 1867. See Muthesius, *The English Terraced House*, p. 60.

9. Outside toilets were still being built in the 1920s.

10. Borough of Sunderland, *Endorsement on Building Plans*.

11. Daunton, p. 250.

12. Borough of Sunderland, *Bye-laws as to new streets and buildings, under the Local Government Act of 1858 etc.* (J. Huntley & Son: 1867) quoted in Muthesius, p. 11.

13. Muthesius, p. 137.

14. *Building News*, 30 July 1897, p. 184.

15. Muthesius, p. 140.

16. Some cottage streets were, in fact, 40 feet wide. St Luke's Road, which includes two-storey buildings, was 50 feet wide.

17. Long, p. 109.

Chapter 3

1. Muthesius, p. 229.

Chapter 4

1. Long, p. 99.

2. G. Potts, 'Growth of Sunderland' in Milburn and Miller, p. 65.

3. See Daunton, *House and Home in the Victorian City*, p. 114.

4. It was common for street names to be drawn from recent military history. In Pallion, for example, Mafeking Street was named after the Siege of Mafeking (1899–1900), a British Victory in the Second Boer War.

5. See TWAS 269/922, a plan of twenty-four cottages in Cairo Street for the Wearmouth Coal Company, dated 28 August 1900.

6. TWAS 269/1917, a plan of fifteen houses in Empress Street for Monkwearmouth Coal Company, dated 18 March 1880.

7. Sunderland Heritage Forum (2010), *What's in a Name: Street Names of Sunderland*. Sunderland: Sunderland Heritage Forum, p. 66.

7. TWAS 269/5693, a plan of eighty cottages in Lily, May, Rose and Violet Streets for James Hartley and Co. See also *Sunderland Daily Echo*, 2 June 1896, p. 3 and *Builder*, 5 June 1896), p. 841.

8. Speculative building was also the basis of middle class housing.

9. Sunderland City Council, 'Proposed Sunderland Cottages Conservation Area' (unpublished notes: 2007), p. 1.

10. TWAS 269/5925, a plan of twenty-nine cottages for W. G. Browell, dated 20 December 1898.

11. Samuel Storey quoted in Long, p. 111.

12. Long, p. 98. However, Long does demonstrate that some of the later cottages were designed by W. and T. R. Milburn.

13. Muthesius, p. 251. However, it is possible to trace workers' housing from the adoption of the Public Health Art of 1848 using building plans and committee minute books.

14. Architects designed estate layouts, but once a prototype cottage was built there was a tendency to duplicate it. It is possible that architects were employed primarily for their ability to produce neat drawings that would satisfy the building committee.

15. *Sunderland Herald*, 14 August 1857, p. 4.

16. *Sunderland Daily Echo*, 26 August 1879, p. 3; 26 May 1884, p. 2.

17. Although part of the ABC Streets, Farnham Terrace consists of two-storey houses and has no cottages.

18. This is true of most cottage plans, but the latest examples – those designed in the 1920s and 1930s – often do include elevations, probably due to the increased stringency associated with government subsidisation.

19. Long, p.106. Similarly, Tom Corfe writes, 'Single-storey cottage streets were built on Wearside from about the 1840s to the First World War'. Corfe, T. (1983) (ed.) *Buildings of Sunderland 1814–1914*. Sunderland: Tyne and Wear County Council Museums, p. 12.

20. See TWAS 269/2180, a plan of nine cottages in Forfar Street for C. B. Carr, dated 14 April 1926. See also TWAS 269/3587, a plan of seven cottages in Inverness Street for Rackstraw and Thompson, dated 10 October 1923.

21. See TWAS 269/3587, a plan of seven cottages in Inverness Street for Rackstraw and Thompson, dated 10 October 1923.

22. See TWAS 269/4087, a plan of twenty one cottages in Mafeking Street for J. W. White, dated 18 July 1924.

23. See TWAS 269/5918, a plan of six cottages in St Leonard's Street, dated 13 February 1924.

24. Information from John Tumman.

Chapter 5

1. Few working class dwellings had a hall entrance in the nineteenth century.

2. In particular, Kerr recognised that the organisation of domestic space influenced the formulation of gender roles within society. See R. Kerr, 'Observations on the plan of Dwelling Houses in Towns' in *Journal of the RIBA*, 3rd series (1894), pp. 201–31.

3. *Ward's Directory* for Sunderland, 1901–2.

4. More specifically, Noble Street had 45 per cent owner-occupancy in 1880. See Platt, M. M. (1991) *The Creation and Development of a Housing Estate: Monkwearmouth estate, Sunderland, 1863-1879*. Unpublished dissertation, University of Sunderland, pp. 106–7.

5. Daunton, M. J., pp. 197–8; Longstaffe, op. cit., 1982.

6. Potts, G. 'Growth of Sunderland' in *Sunderland: River, Town and People*, p. 65.

7. *Sunderland Herald*, 7 April 1865, p. 8.

8. Potts, G. 'Growth of Sunderland' in *Sunderland: River, Town and People*, p. 65.

9. *Sunderland Times*, 29 February 1868.

10. *Cost of Living Report*, Parliamentary Papers, CVII (1908), pp. 191–2.

11. Muthesius, p. 236.

12. J. Glyde, 'a nineteenth-century observer,' quoted in Long, p. 103.

13. Muthesius has discussed this issue at greater length. Muthesius, *The English Terraced House*, p. 237.

14. A. H. Halsey quoted in Long, p. 101.

15. Graham Potts has demonstrated that housing patterns in Sunderland were shaped by those with financial power and mobility. Potts, 'Growth of Sunderland', p. 59.

16. Long, p. 114.

17. Saddon, S. A. (1964) *Tramways of Sunderland*. Huddersfield: Advertiser Press.

18. These social facilities tended to follow the construction of streets, following the movement of population out of the town and into the suburbs. The church of St Gabriel was designed in an innovative Art Nouveau style by C. A. Clayton Greene, a local architect who, with his partner Hugh Taylor Decimus Hedley, had designed cottages in Grosvenor Street (1900–5) and Trinity Street (1903–7). Barnes School was the first Council School in Sunderland, although it had been planned by the School Board.

Chapter 6

1. Dennis, N. *People and Planning*, p. 214.

2. *Sunderland Echo*, 11 November 1965.

3. See Dennis, N. *People and Planning*, p. 212.

4. Email correspondence from Norman Dennis, 2007.

5. Email correspondence from Norman Dennis, 2007.

6. Hudson, B., Obituary of Norman Dennis, *The Guardian*, 28 November 2010.

7. English Heritage 06; management plans guidance.

Conclusion

1. See Long, A., *op cit.*, pp.97–122.

# Bibliography

Borough of Sunderland, *Bye-laws as to new streets and buildings, under the Local Government Act of 1858 etc.* (Sunderland: J. Huntley & Son, 1867)

Cookson, G., *Sunderland: Building a City* (Chichester: Phillimore, 2010)

Corfe, T. (ed.), *Buildings of Sunderland, 1814-1914* (Sunderland: Tyne and Wear County Council Museums, 1983)

Corfe, T., *Wearmouth Heritage* (Sunderland: Sunderland Civic Society, 1975)

Daunton, M. J., *House and Home in the Victorian City: working class housing 1850-1914* (London: Edward Arnold, 1983)

Dennis, N., *People and Planning: the sociology of housing in Sunderland* (London: Faber and Faber, 1970)

Dennis, N., *Public Participation and Planners' Blight* (London: Faber and Faber, 1972)

Gauldie, E., *Cruel Habitations: A History of Working-Class Housing, 1780-1918* (London: George Allen and Unwin, 1974)

Grundy, J., *Northern Pride* (London: Granada, 2003)

Johnson, M., 'The Sunderland Cottage: the favourite and typical dwelling of the skilled mechanic' in *Vernacular Architecture*, Vol.41, 2010, pp. 59-74.

Johnson, M. and Potts, G., *The Architecture of Sunderland, 1700-1914* (Stroud: The History Press 2013)

Long, A., 'The Sunderland Cottage' in Faulkner, T. (ed.) *Northumbrian Panorama* (London: Octavian Press, 1996)

Milburn, G. E. and Miller, S. T. (ed.), *Sunderland: River, Town and People: a history from the 1780s* (Sunderland: Sunderland Borough Council, 1988)

Muthesius, S., *The English Terraced House* (New Haven: Yale University Press, 1982)

Saddon, S. A., *Tramways of Sunderland* (Huddersfield: Advertiser Press, 1964)

Smith, J. W. and Holden, T. S., *Where Ships are Born, Sunderland 1346-1916* (Sunderland. Thomas Reed, 1946)

Stevenson, J. J., *House Architecture* (London: Macmillan and Co., 1880)

Sunderland City Council, 'Proposed Sunderland Cottages Conservation Area,' unpublished notes (2007)

Sunderland Heritage Forum, *What's in a Name: street names of Sunderland* (Sunderland: Sunderland Heritage Forum, 2010)

Sutcliffe, A. (ed.), *Multi-Storey Living: The British Working-Class Experience* (London: Croom Helm, 1974)

Tarn, J. N., *Five Per Cent Philanthropy: an account of housing in urban areas between 1840 and 1914* (London: Cambridge University Press, 1973)

# Index